FORMBY & FRESHFIELD

THROUGH TIME

Reg & Barbara Yorke

AMBERLEY PUBLISHING

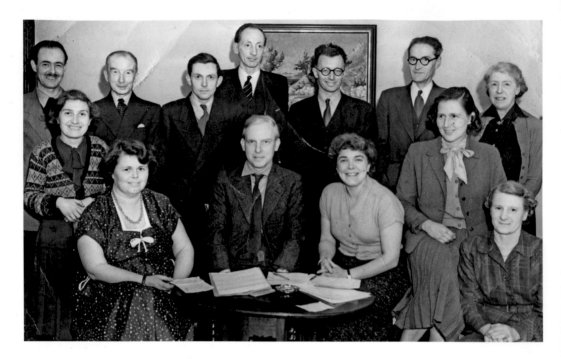

Most of the early illustrations in this book are from the Formby Civic Society, formed in 1953 and still 'going strong'! This was the founding commitee chaired by Prof Tom Kelly.

First published 2009

Amberley Publishing Plc
Cirencester Road, Chalford,
Stroud, Gloucestershire, GL6 8PE

www.amberley-books.com

Copyright © Reg & Barbara Yorke, 2009

The right of Reg & Barbara Yorke to be identified as the
Authors of this work has been asserted in accordance
with the Copyrights, Designs and Patents Act 1988.

ISBN 978-1-84868-295-5

British Library Cataloguing in Publication Data.
A catalogue record for this book is available from
the British Library.

Typeset in 9.5pt on 11pt Celeste.
Typesetting by Amberley Publishing.
Printed in the UK.

Introduction

It is often said that we don't notice the changes that are continually taking place around us until we happen to see an old photo and only then realise what changes have occurred. The 'Through Time' formula, taken to a peak of perfection by Alan Sutton, has enabled us to focus on just a few of the local changes that have occurred, often when we were 'too busy to notice'.

Formby is fortunate in possessing more of a visual record then many bigger and more important places. Thanks are due in this respect to the founder members of the Formby Civic Society, who are now hardly remembered.

They would, we are sure, be delighted that their excellent photos are still being looked at and enjoyed. Muriel Sibley was, however, the most assiduous recorder of the past, She is now remembered mainly for her watercolours and line drawings, but it is not widely known that for every sketch or painting, she also photographed several colour transparencies.

As a result, the Formby Civic Society not only possesses some 700 of her sketches but several thousand related photographs. Taken at a time when Formby was beginning to change rapidly, a process that continues to this day, this is a most valuable and indeed evocative archive.

It is an interesting experience, as we have discovered, to identify the exact place where she set up her easel and camera and to look at the same scene through the camera viewfinder today.

Not only has her recording tradition being continued but we now have additional sophisticated computer techniques for recording, cataloguing, retrieving and re-presenting visual images in digital format. Muriel and her contemporaries would possibly be rather amazed by the technical advances we now enjoy. These, however, do present challenges and Barbara and I have been very grateful for the technical help which we have been freely given by Tony Bonney, not only in the production of this book but for the last two

to three years in the 'digitisation' of the Formby Civic Society's entire visual archive.

Tony has put in an immense amount of time and effort not only in this but also some twenty volumes of old *Formby Times* newspaper cuttings. Unfortunately, the scope of the present publication does not do justice to the vast amount of information that can now be retrieved. We hope, however, that although this is perhaps a superficial look at our recent past it will revive memories and recollections. If you have further information on the changes we have illustrated please let us know.

Reg and Barbara Yorke.

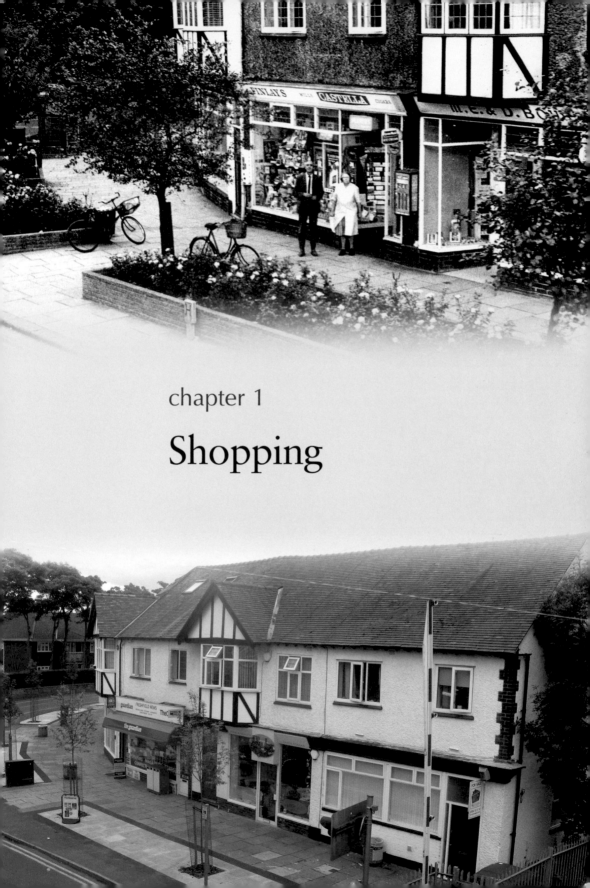

chapter 1

Shopping

Chapel Lane

The corner of Elbow Lane and Chapel Lane has changed dramatically during the last century. Now, you are more likely to meet a 4x4 than a cow! Children would now have to visit farms to see these animals. The road in the earlier picture is obviously in the process of being surfaced with stone sets. Even main roads used to be sandy. The thatched house hidden behind the trees in the upper photo has now been replaced by a row of shops, but despite the modern shop fronts, the buildings on the left are basically the originals.

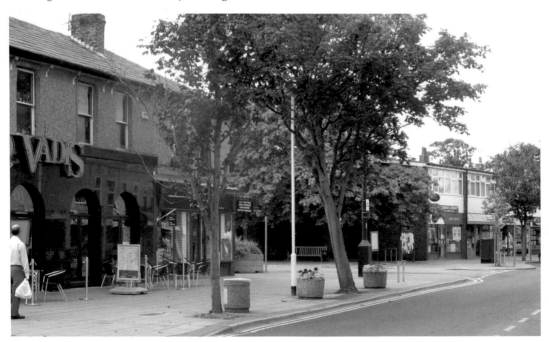

Chapel Lane, July 1977

These two cottages, with their front gardens extending to the pavement, were the last to be demolished on the north side of Chapel Lane. This clearly shows how today's wide pavements in the village centre came about. The new (Midland) bank was extended and shops with flats above finally replaced these cottages. The large pear tree between the bank and cottages, the remains of a garden, has gone and the trees on the pavement edge have been replanted.

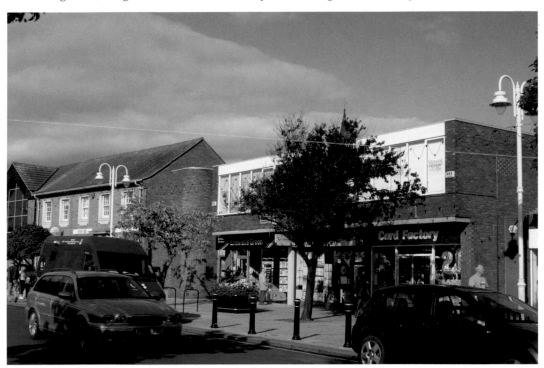

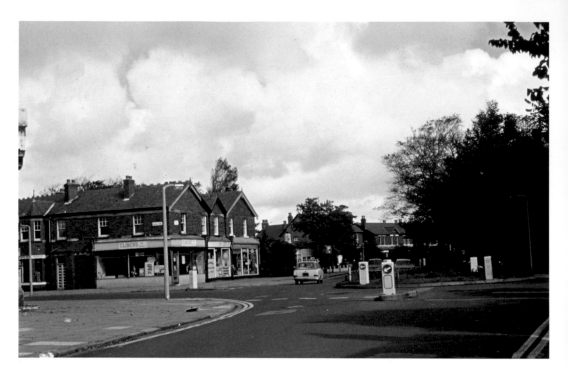

Chapel Lane *c.* 1960

Halsall Lane corner. One of the most changed corners of the village centre is situated here. This corner shop commenced in the late nineteenth century as a grocer's shop occupied by a Mr Slater, who was succeeded by two sons, Wilf and Neville. They in turn retired in 1950 and then various traders took over the premises and finally the rest of the block. Older residents will remember Mr Needham, who had an electrical shop. The village library and the *Formby Times* office were also there. There is now a restaurant, a dress shop, an optician and various other businesses in the striking new building now occupying the site.

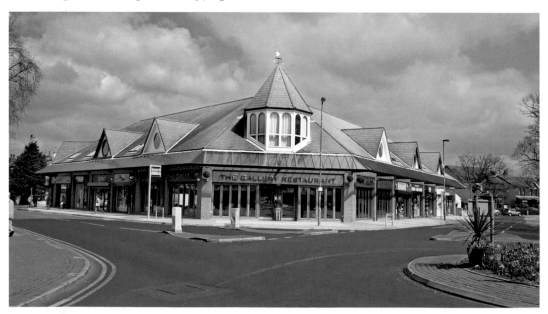

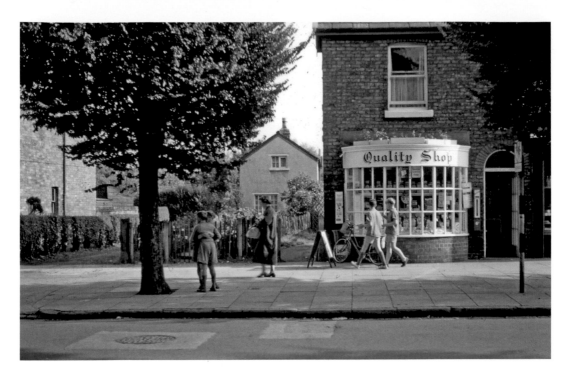

Chapel Lane

The 'Quality Shop'. Photographed 1960. At one time, the village had very varied shop fronts. Today, they all look much the same. Many a child must have bought dolly mixtures in handmade paper bags from the Quality Shop. Here again, in the upper photo, we see one of the surviving cottages still standing in the village centre in the 1960s. There was plenty of space behind these shops, which has long been one of our much-used, free village car parks.

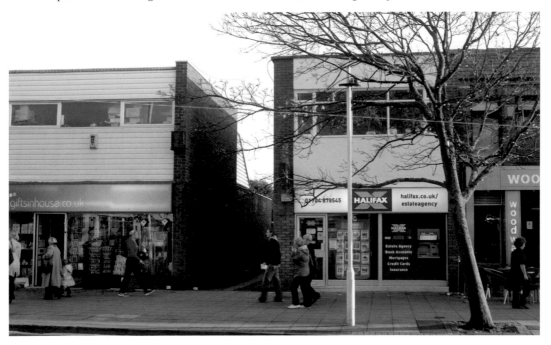

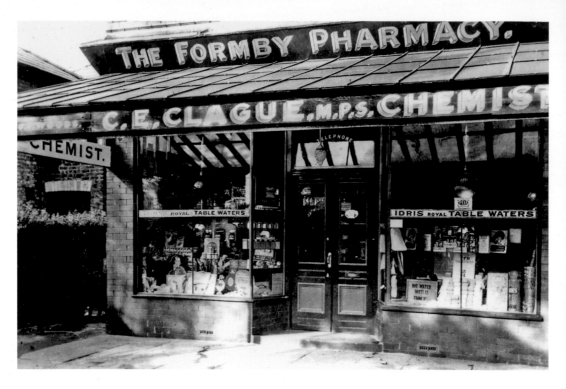

Clague's Chemist Shop, later McDougall's, Chapel Lane, 1920s

The change to the present day is very striking. We also now have a number of pharmacists in Formby away from the centre, one in Harrington Road and another in Little Altcar. Chemist shops have altered over the years, but an early advert for Clague's offered their services in Esperanto!

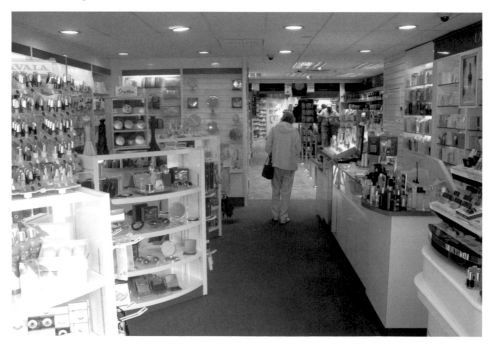

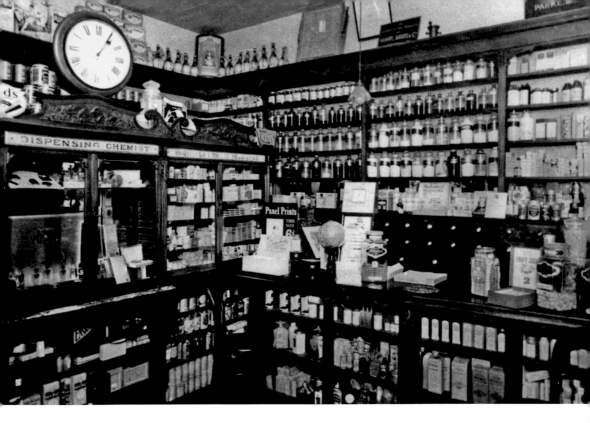

Mr Clague's Pharmacy, now Rowlands

Was previously owned by a Joseph Woods. Mr Clague had the veranda removed in the late 1930s and then modernised the shop front. A hedge ran along the left edge of the shop in the days before the building on that side (now a doctors' surgery) was taken over from Irwin's, the grocer's.

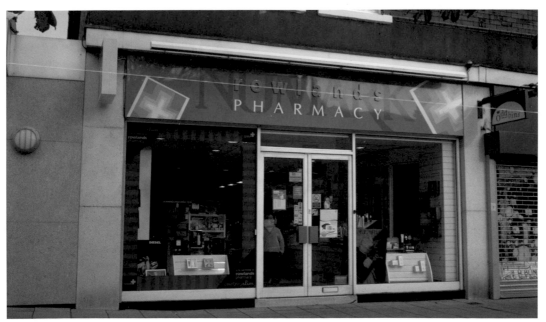

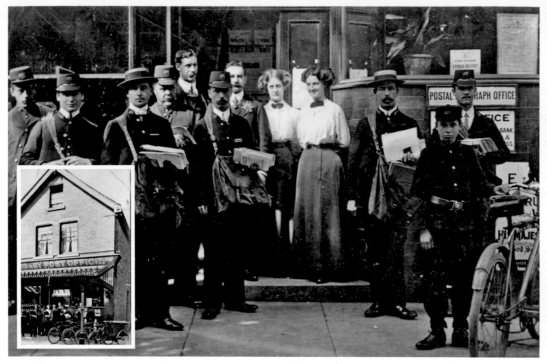

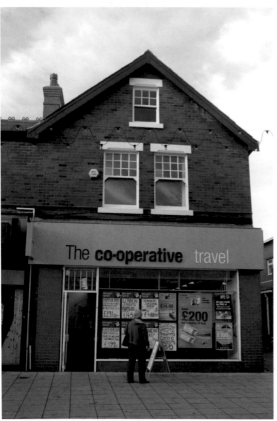

Chapel Lane

The old post office, photographed 1911, was then managed by a Mr Beardwood, the father of one of Formby's local historians. The basic structure of these shops hasn't changed, but their use certainly has. This well-manned post office subsequently moved to a handsome 1930s building but more recently reverted back to being housed in a typical modern shop on the other side of the road. Many of the village centre shops have recently become bars, but some, like this one, have obviously made a successful transition, in this case a travel agent.

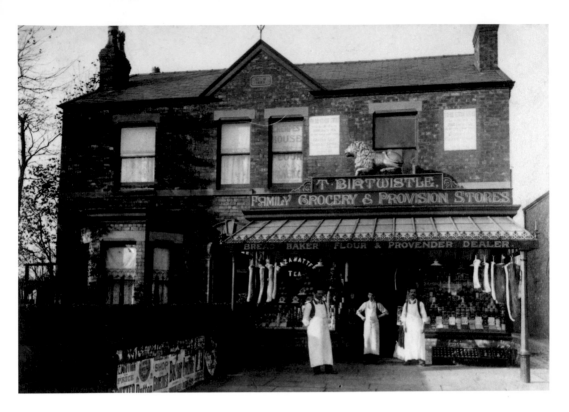

Birtwistles, 1920s

This was a well-known grocer's shop, built in 1888. The adjacent house became the gas showrooms and, during the Second World War, was the local food office. It later became a grocer's shop but finally is today a Boots the Chemist. In the days when it was the gas showrooms, it had a meeting room on the first floor where the then Formby Society often held its meetings.

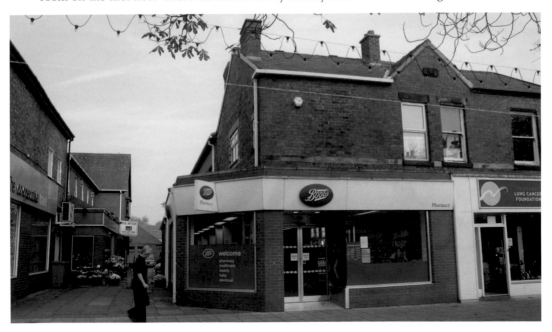

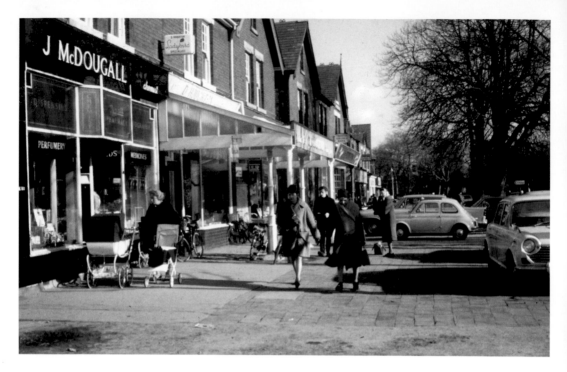

Chapel Lane

These shops adjacent to McDougall's have, with modernisation, unfortunately lost their verandas. Paving stones seen here have now been replaced, but at the time the earlier photo was taken, many cars started parking on the pavements, a practice which has since been disallowed and indeed prevented by bollards! A recent development has been the appearance of metal shutters across many shop windows. Some of these are very solid and prevent any sight through the window at night and weekends. This is an unfortunate tendency, but the shop here shows a much more acceptable form of grill.

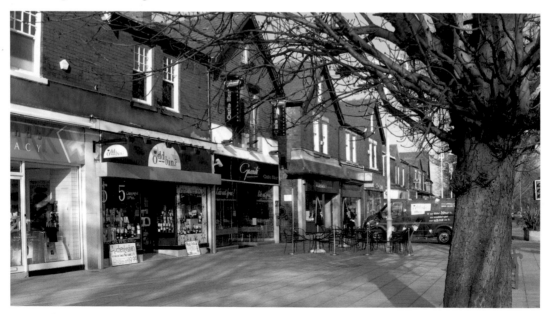

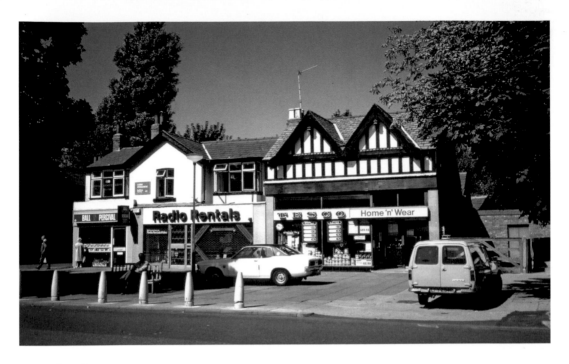

Chapel Lane

Irwin's grocer's shop, easily identifiable by its characteristic architecture, here seen in Chapel Lane, gave way to Tesco, which finally moved to a large, new superstore on a site across the Formby bypass. The premises seen above recently became converted to a doctor's surgery. The increased number of bollards in the lower photo indicates the stronger line now taken on pavement parking.

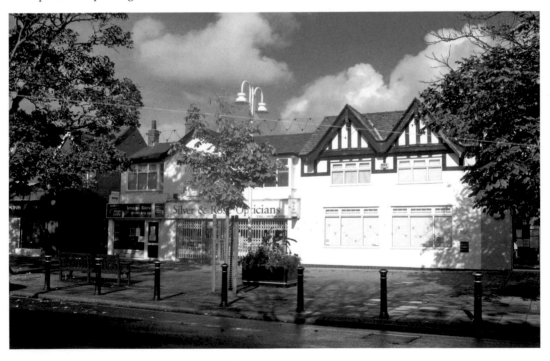

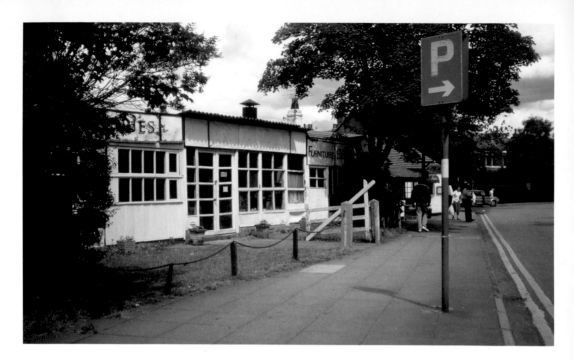

School Lane

'The Homesteader', photographed in 1988, in the earlier of these photos, sold second-hand furniture and Mr Nimmo the owner was an excellent joiner. He eventually retired, and afterwards, the whole of this corner was redeveloped. Unfortunately, some of this row of smart new shops are still empty, but the restaurant at the end is a listed building, and was once Formby's first school.

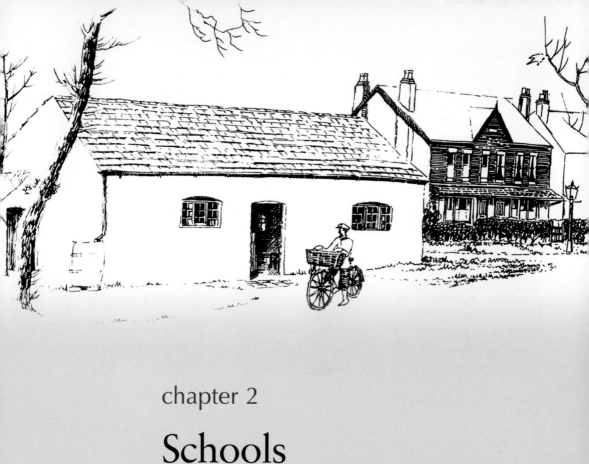

chapter 2

Schools

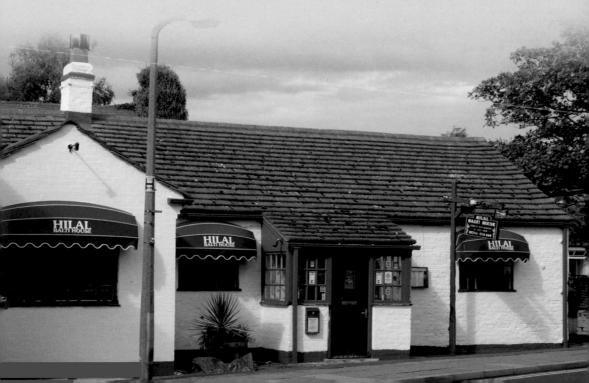

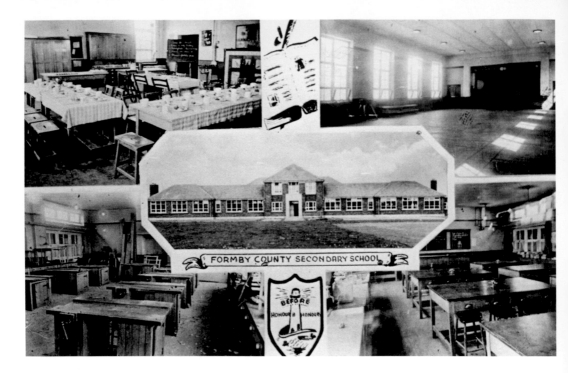

Formby High School, Freshfield Road

This school was built on farm land between Freshfield Road and Gores Lane just before the Second World War and was then used not only by local children but also evacuees. It is now much enlarged and has 1,000 pupils. Formby now also possesses a second high school, Range High School. Formby High gets good results and has adequate playing fields round the main buildings.

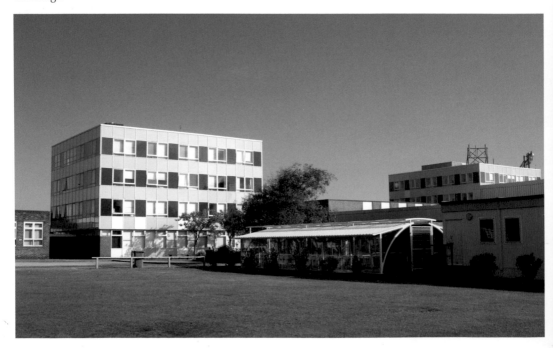

St Luke's First School, Photographed 1976

This school, built outside the new ecclesiastical parish, was on the corner of King's Road and Ravenmeols Lane. This site is now occupied by a block of flats. A replacement junior school was built in 1910 in Jubilee Road after much argument. The then vicar actually wanted it nearer the church.

You can tell by the roofline of the school in Jubilee Road today that, over the years, this very popular and successful school has been much extended but still retains its original core building. The area to the left of the schoolyard is a quiet area for children who want to be on their own for a while.

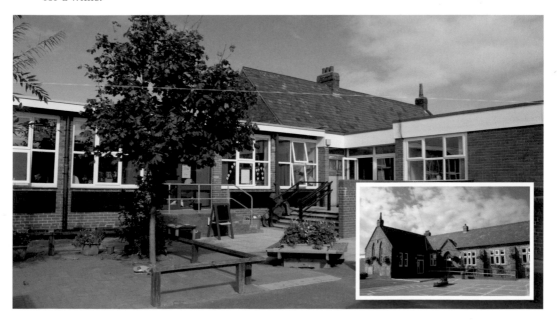

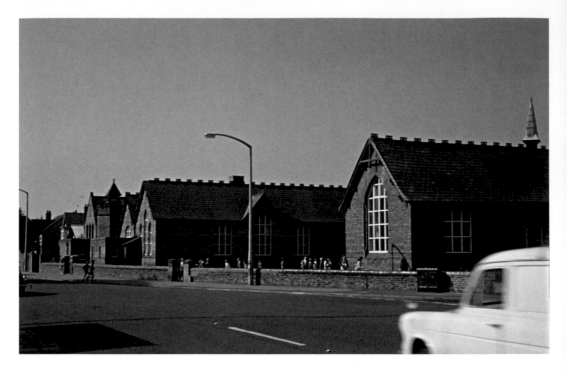

Our Lady's School, Founded in 1871, Photographed 1984
Was formerly in Liverpool Road. It eventually moved to Bull Cop. After losing a splendid, large copper beech tree from the corner of the playground, it looked rather bleak. Now, having moved to a more attractive and spacious site at Bull Cop, the old site has become yet another large block of flats.

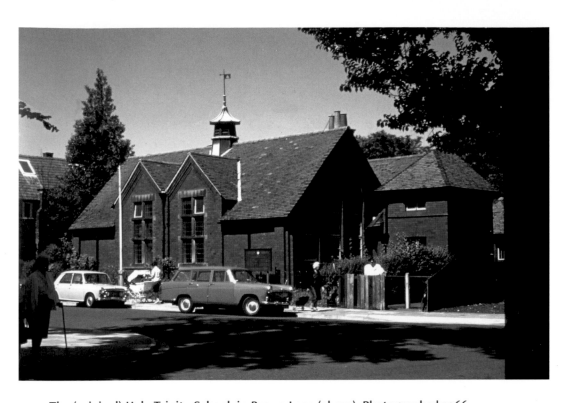

The (original) Holy Trinity School, in Brows Lane (above). Photographed 1966
The school later transferred to new buildings in Lonsdale Road. It has since been amalgamated with St Peter's School in Paradise Lane and renamed Trinity St Peter's School. The relatively new building in Lonsdale Road (see insert) is now closed and unused.

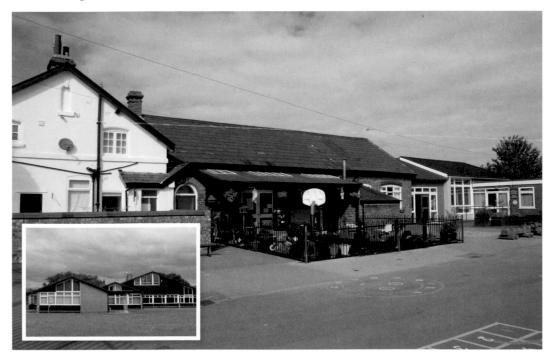

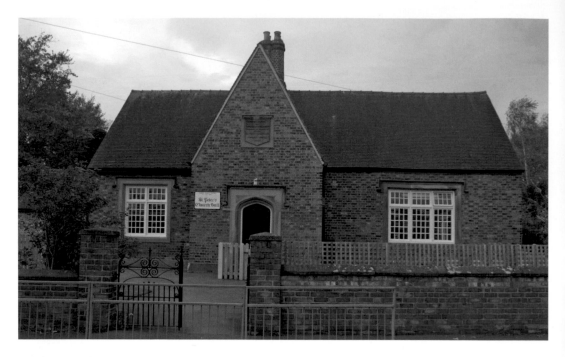

Schools No Longer!

This former 'School for female children', (top) was endowed by the then Lord of the Manor, the Rev Richard Formby, in 1832. Since a modern school building was built it has been used as the St Peter's Church Hall and a portion at the rear as a pre-school nursery. The former Ravenmeols's County Primary School, (below), is also no longer a school but mainly used as a Professional Development Centre for teachers from the Sefton Metropolitan Borough area. Part is also used as the Ravenmeols Community Centre and is where the Formby Civic Society and other local groups regularly meet.

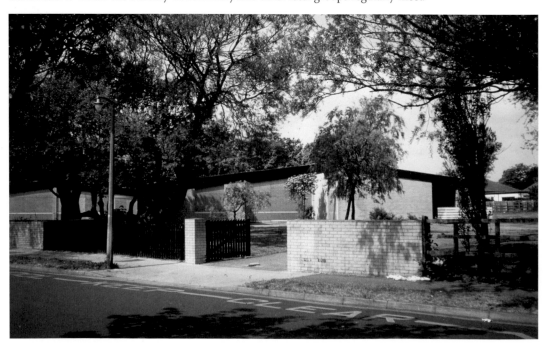

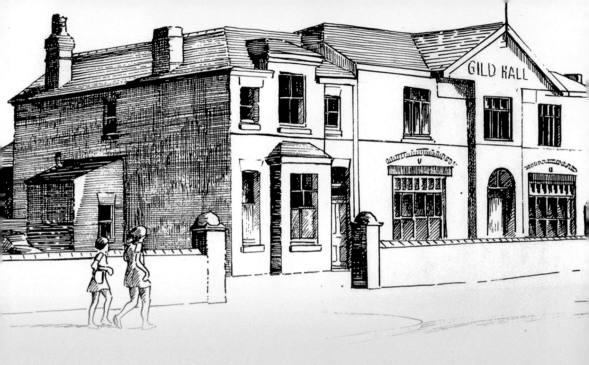

chapter 3

Leisure

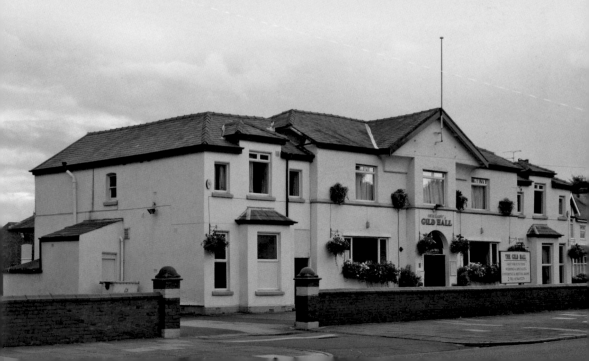

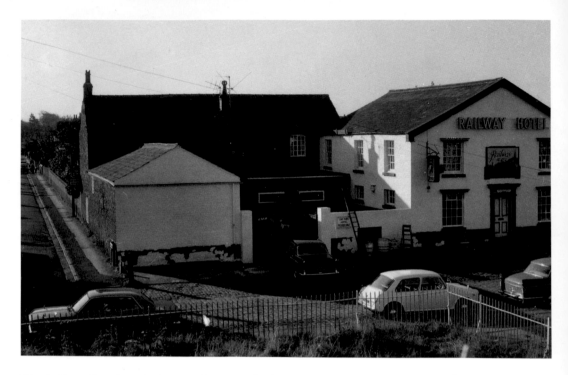

The Railway Hotel, Duke Street. Photographed 1970
The Railway Hotel is one of many old, established Formby Pubs. Before the construction of Station Hill, it stood beside a level crossing. Like most other local pubs, it had a bowling green, now a car park. At one time it also had a mortuary where bodies found on the shore were brought for identification and suitable disposal.

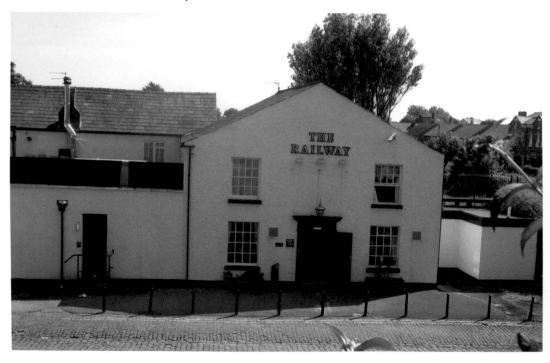

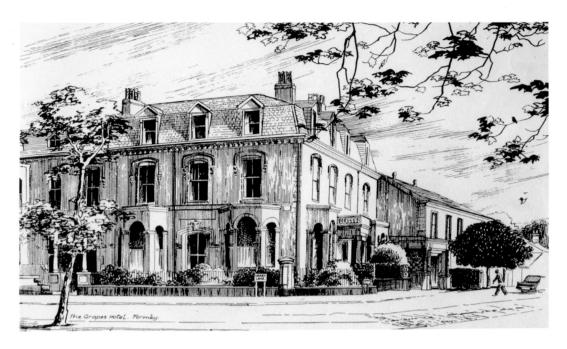

The Grapes Hotel. Formby

The Grapes Hotel, Green Lane. Photographed 1969

Built in the 1870s, it has a Victorian dignity of proportion, and additions made at various times have been in keeping with its position at the entrance to a conservation area. Until the Victoria and Gild Halls were built, any gathering of any size took place in the Grapes Assembly Room, but this happens no longer, and the hotel no longer offers accommodation or a bowling green. You can still see the beech trees that marked a running track round the bowling green and the mounting block by the side of the entrance to help you get on or off your horse. Pioneer airmen flying off the beach at Freshfield in 1910 took refreshment there before returning home.

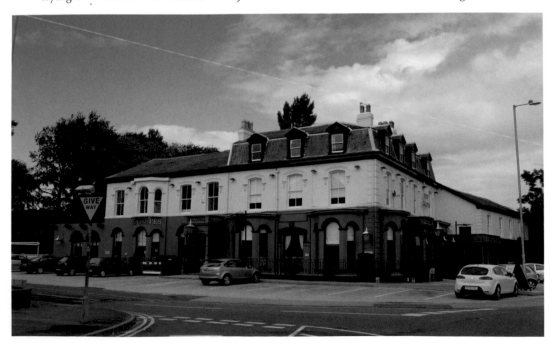

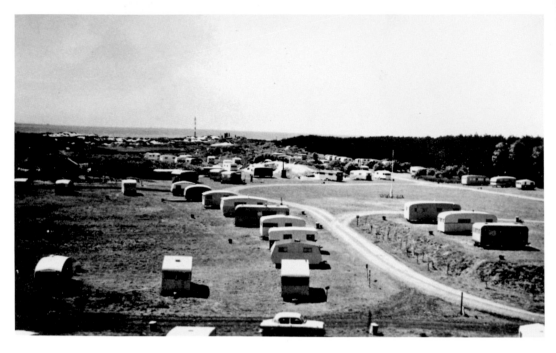

Formby Point Caravan Site, Lifeboat Road

Lifeboat Road has always been a popular place for caravans. It is well spaced out and, because of 'sand-winning' (extraction of sand) in the past, provides a level, sheltered and protected site. Many people have had their caravans permanently here for years. The grassed-over edge of the former sand-quarry is visible in the lower photo taken looking inland. Note how the style and size of caravans has changed over the years!

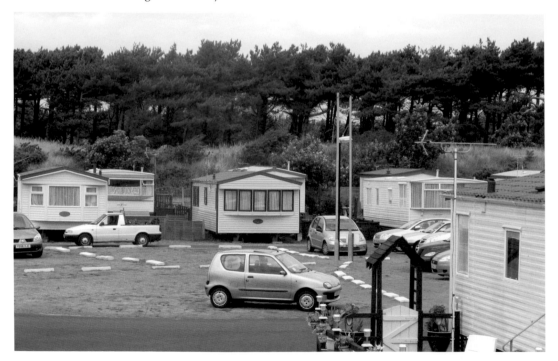

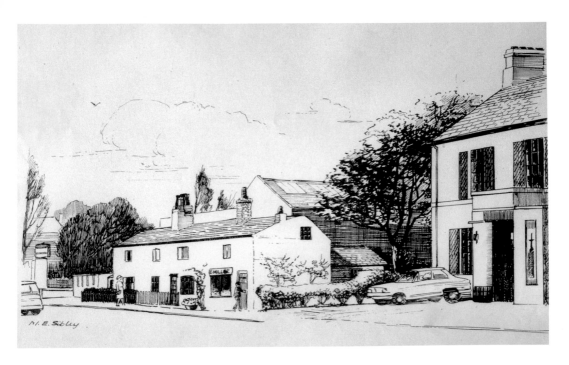

The Royal Hotel, Liverpool Road. Photographed 1972

This pub has also developed an outside drinking area but has sold off its bowling green for a future housing development. The cottages to its left have also long since gone being replaced by a petrol station, which has now also recently been demolished. The Royal Hotel had a very good meeting room and provided headed paper for writing letters. During the Second World War, servicemen from Altcar engraved their names on an internal window (unfortunately since lost) before going on active service.

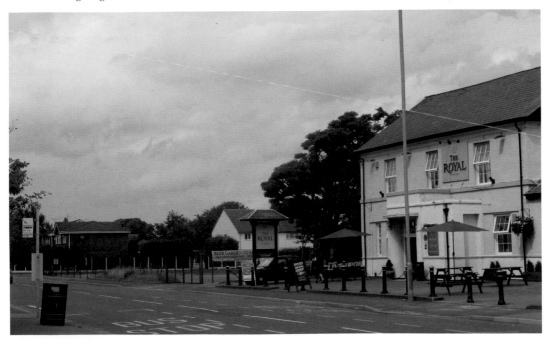

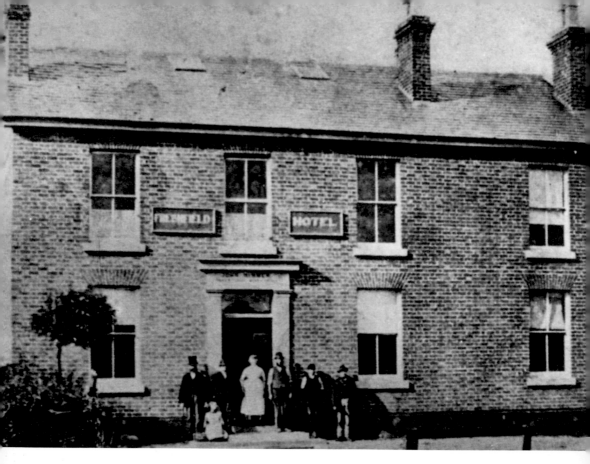

The Freshfield Hotel, Massam's Lane. Photographed 1900
This pub at the corner of Massam's Lane and Gores Lane has been extended since the first photograph was taken over 100 years ago and its doorway has moved. It has always been a popular pub, nowadays specialising in a great variety of real ales and made attractive by its hanging baskets, a side entrance for wheelchair users, and open-air tables at the side and rear. It also has a meeting room for up to eighty people and, having lost its bowling green, has extensive parking.

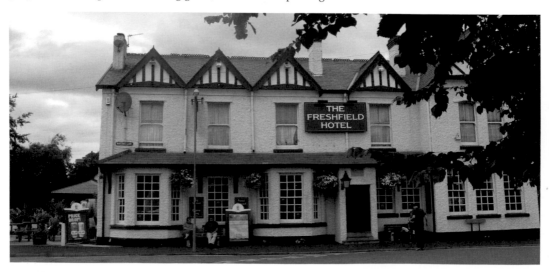

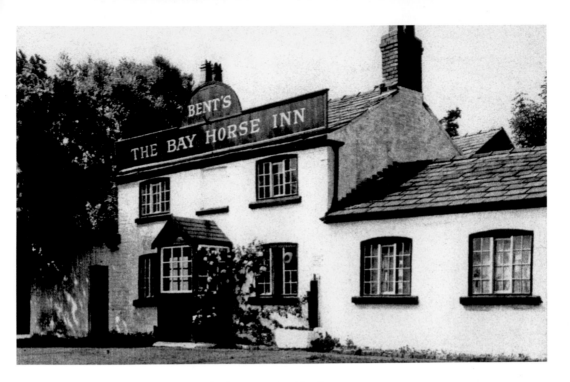

The Bay Horse, Liverpool Road. Photographed in the 1950s

This is one of Formby's oldest pubs, but in recent years, it has been considerably enlarged and changed internally and extended. The field to its right once provided the site for an annual travelling fair but has long since become a well-used car park. It has also developed an attractive outside drinking area, even though very near the main road.

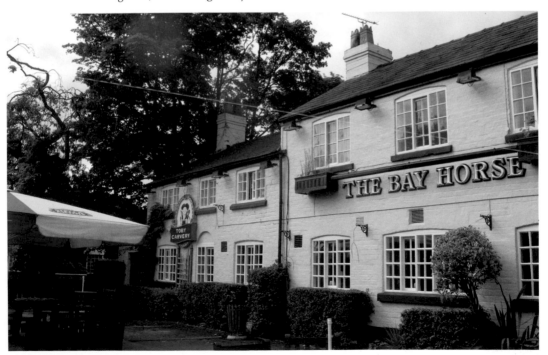

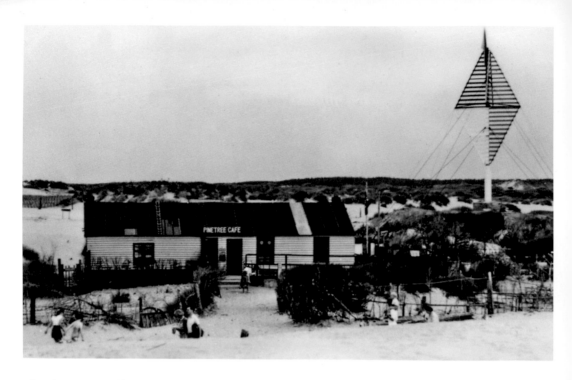

The Pine Tree Café

At the end of Victoria Road, the Pine Tree Café for many years provided welcome refreshments but, owing to coastal erosion, fell into the sea. Its only remains are now visible as rubble on the beach. The large navigation beacon has gone the same way, but fortunately, in these days of radar and other navigation aids, such visual 'landmarks' are no longer necessary for the shipping entering the busy River Mersey.

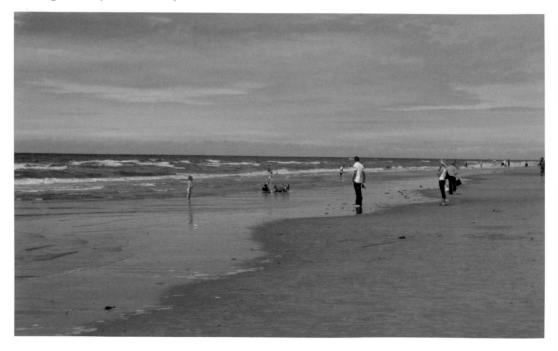

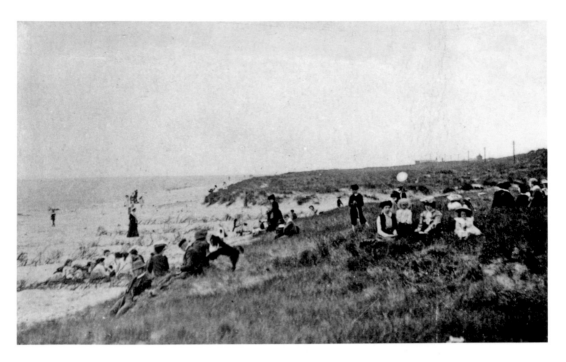

Formby Point, Lifeboat Road; Summer Visitors
Things have not much changed since the Edwardian period. Formby shore remains a favourite place for people to visit, in spite of the long trek from the station (before people came by car), as is shown by these two photographs taken approximately one hundred years apart.

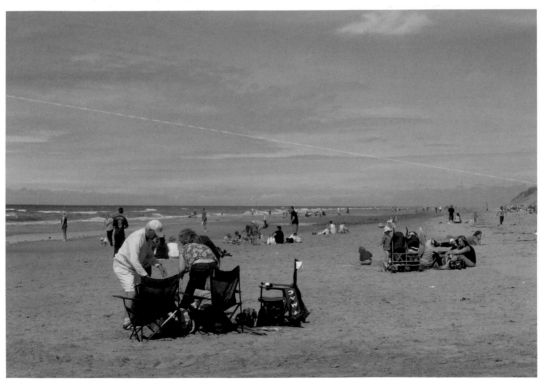

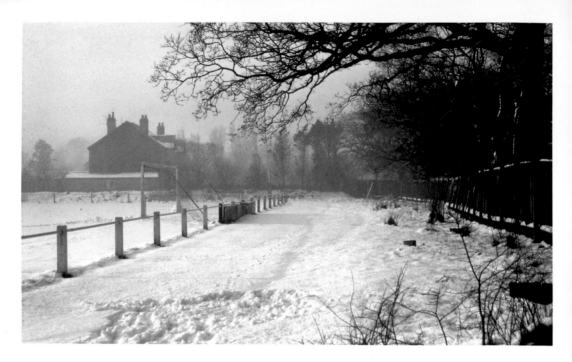

The Former Formby Football Club ground, Brows Lane

(Here seen in winter 1982) is now the site of Formby's long-awaited swimming pool. This plot of land, formerly a farmer's field, was given to returning soldiers for use as a football pitch after the First World War. Recently, the ground was relinquished by the football club in favour of a new ground to the east of the bypass. This site was then purchased for the construction of the pool. This splendid building, largely provided by means of philanthropic financial support, has two pools, one for adults and one for children. There is also a cafeteria and even a boules court, surrounded by informal but interesting landscaping.

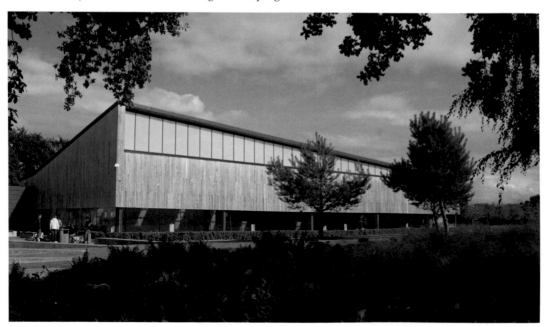

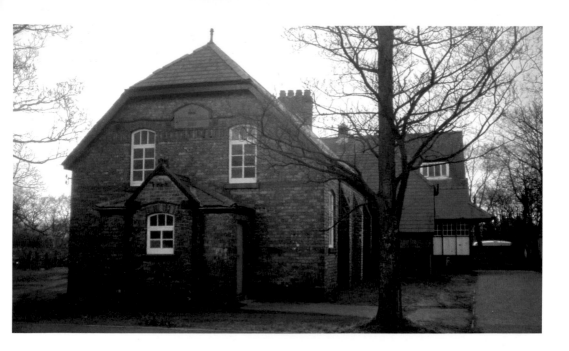

The Victoria Hall, Timms Lane

Externally not much altered since Formby's oldest church hall was built in 1885. It has been widely used by the community for playschool, badminton, whist drives and dances (reputed to have one of the best sprung dance floors in the north-west). Soldiers were billeted there in the First World War, and during the Second World War, hundreds of soldiers, some injured, returning from Dunkirk, were housed in it. It was later used as a forces canteen. During one period of four days, the quarterfinals of the army boxing championships were staged there, and ENZA presented shows to the troops on Sunday evenings. During the blitz on Liverpool, the hall was used for children evacuated from bombed areas and it was even home for a fortnight for people evacuated from Harrow during 'doodlebug' raids. In 1970, it was handed over by the church to a special committee, but now, in 2009, it has been taken over by a dancing school!

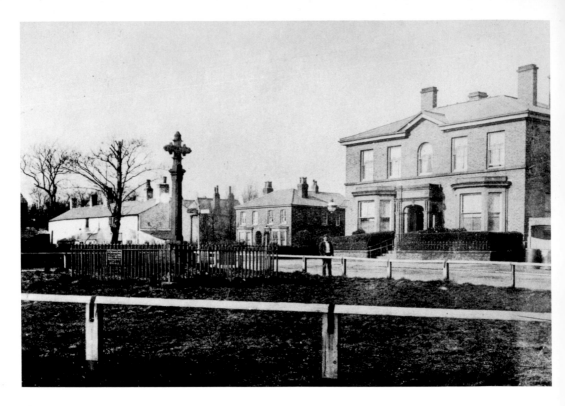

The Cross House

An old and attractive pub, formerly known as the Blundell Arms, it no longer offers accommodation but does serve good meals. This pub has also lost its bowling green to provide a car park but that space is in fact now being considered for provision of extra housing!

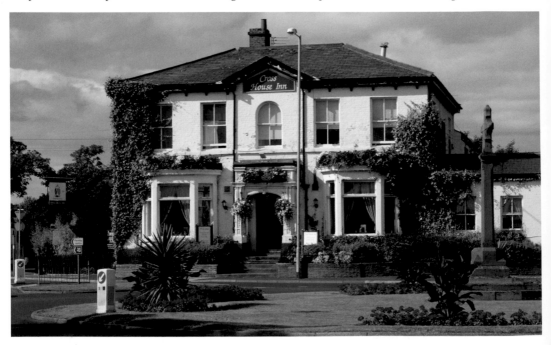

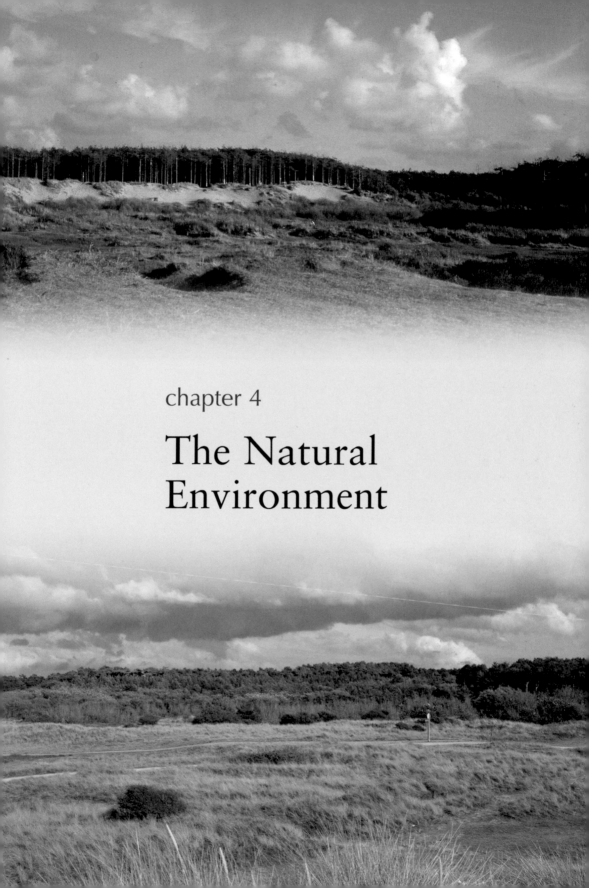

chapter 4

The Natural Environment

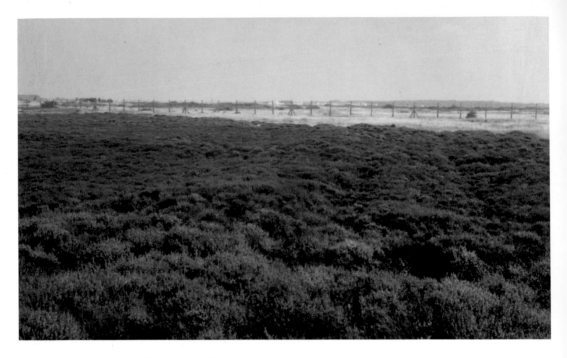

Dune Heath at the Southern End of RAF Woodvale Airfield
Most of this area was, prior to the Second World War, farmland, but part had, by then, become a golf course. After the war, much of the disused periphery of the airfield naturally reverted to its original dune heath state but, as with all heathland without grazing or management, gradually 'scrubbed' over and would eventually become woodland, as seen in the present-day view below. Now managed by the Lancashire, Manchester & Merseyside Wildlife Trust, grazing has been reintroduced to maintain the nationally now-rare heathland status.

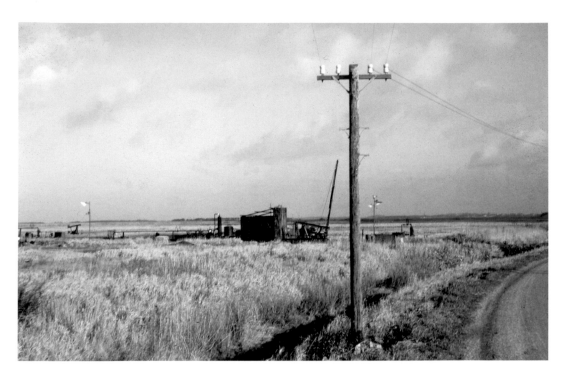

Formby Moss, the Oilfield Pumps. Photographed 1964

Oil was discovered under Formby Moss and was, for many years, pumped to the surface by 'Nodding Donkey' pumps. This was fed into the Pluto Pipeline during the Second World War, but now, extraction has ceased and the pumps have been removed.

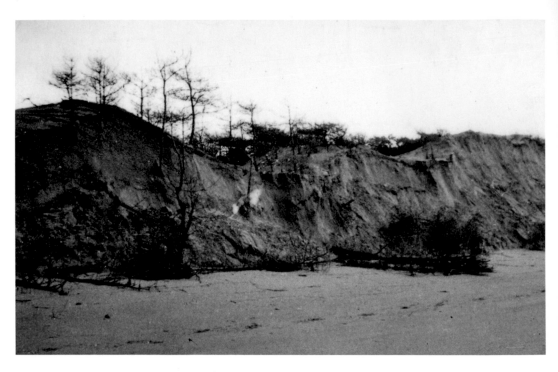

Freshfield Dunes, Erosion and the End of Gypsy Wood
Here we see how the sea is eroding this part of the coast, not prevented in the least by the previous tree planting. Marram grass does, however, help.

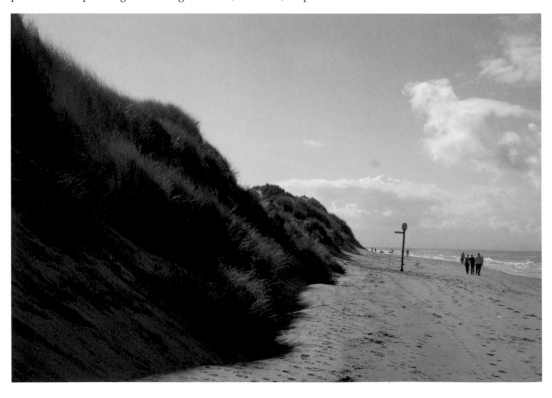

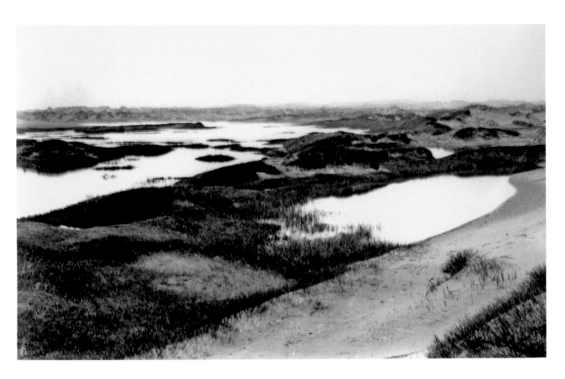

Sandhills, Long Slack or Massam's Slack, Freshfield Photographed in the 1920s
The low-lying hollows (known as 'slacks') between the dunes naturally collect fresh water during the winter months as the water-table is high here. This produces a rare and very interesting habitat with unique plant and wildlife. Unfortunately, the planting of extensive pine plantations has resulted in the lowering of the water-table and consequent drying out of many 'slacks'.

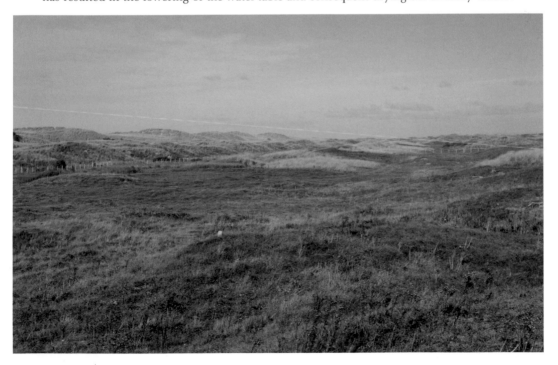

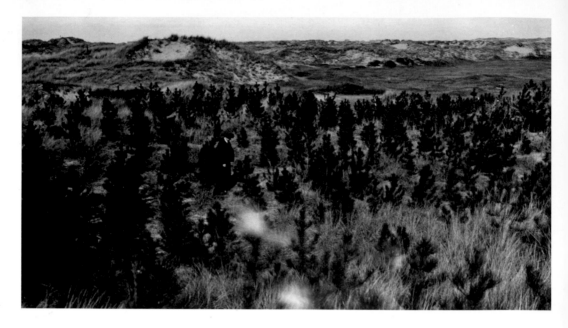

Cloven-le-Dale; Pine Plantations

Above; young pines planted about 1930 (photo courtesy of Natural England). Below; pines in same area as they are today. It was shown in the late eighteenth century that certain conifer species can be successfully cultivated on the dunes, and this was followed by extensive tree planting by the manorial landowners during the late nineteenth century and early twentieth century. Unfortunately, the profits expected were never realised, but many people today like the appearance and 'feel' of the conifer plantations, now managed mainly by Natural England and the National Trust. Much of the former frontal woodlands have disappeared into the sea, been overcome by blown sand or suffered from wind-blow. The more inland trees are, however, home to a now diminishing colony of red squirrels, sadly reduced by a viral disease from 1,000 to about 100 in the last few years.

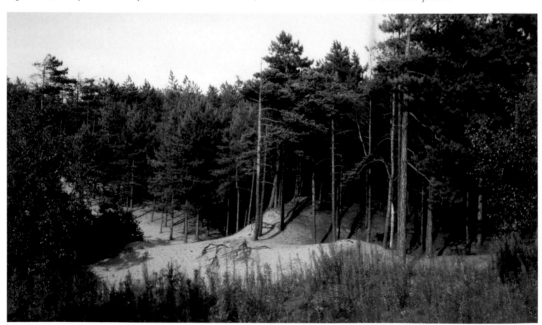

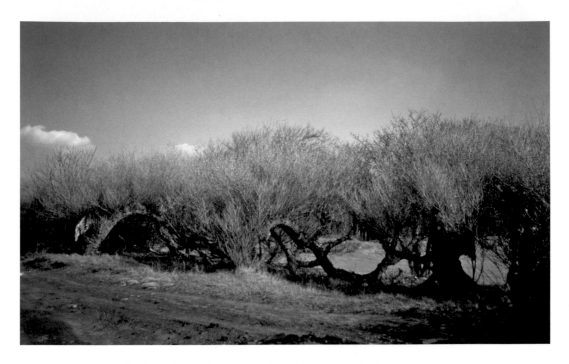

Ravenmeols, Black Poplars Along Albert Road. Photographed 1969

Recent work by natural historian Dr Phil Smith and colleagues has demonstrated that there are about 550 native black poplar on Formby Point. To put this in perspective, the entire county of Cheshire has about 300 and Lancashire 200 specimens. A native species; it seems that some black poplar were in fact planted as an 'amenity tree' in the late nineteenth century, in this case by the then Formby Land Company who tried to establish a brand-new resort to be called 'Formby-by-the-Sea' in Ravenmeols at that time.

Freshfield

Above, 'Nova', a wooden ex-First World War army hut lived in at one time by a lady artist, May Cooksey, well known in the Arts and Crafts Movement, and later the Morice family. The photo was taken after they had moved. The area was allowed to 'return to nature' and was subsequently adopted by St Peter's School and recognised by English Nature with a small grant to aid its conservation as an urban wildlife haven.

chapter 5

Housing

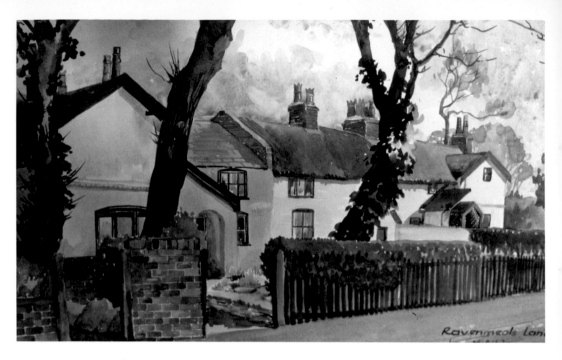

Ravenmeols Lane; Hawes Houses

These old thatched cottages with long gardens stood on the north side of the lane. They sold fresh lettuces and tomatoes. When demolished, they were replaced by a cul-de-sac of about five bungalows, with two facing onto Ravenmeols Lane.

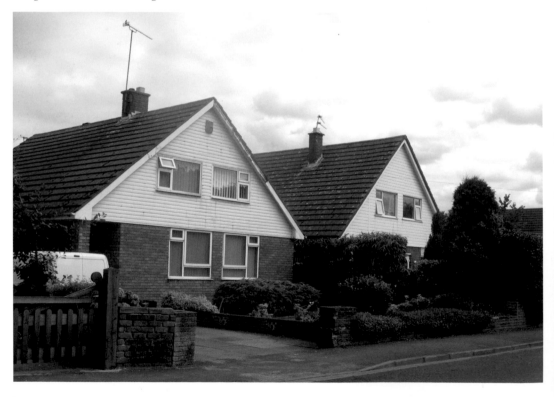

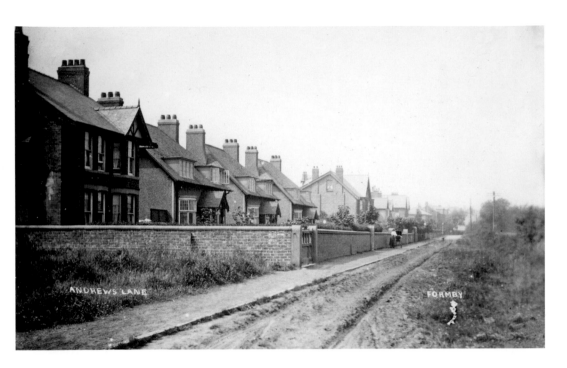

Andrew's Lane. Photographed 1910

These houses were erected along an old pathway at the turn of the early twentieth century, but the side nearest the railway was occupied by railway sidings for many years. Originally, a light railway ran from here down to 'Formby-by-the-Sea' promenade to convey construction materials. Today, there are houses on both sides of the road. Like many Formby roads, the roadway was still just a sandy track at the time the photograph was taken.

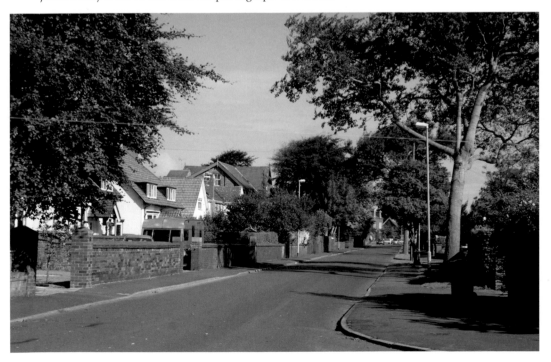

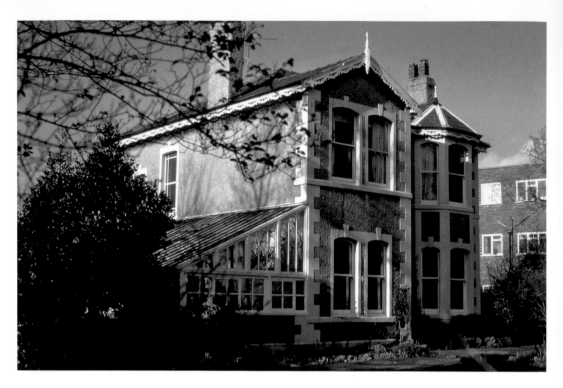

Brows Lane, 'Milverton', Photographed 1971
On the north side of Brows Lane was the former home of Miss Thompson, a local artist. She gave her home to the Abbeyfield Society as a residential home for elderly people. The conservatory was replaced by a two-story extension to provide extra accommodation for its present residents.

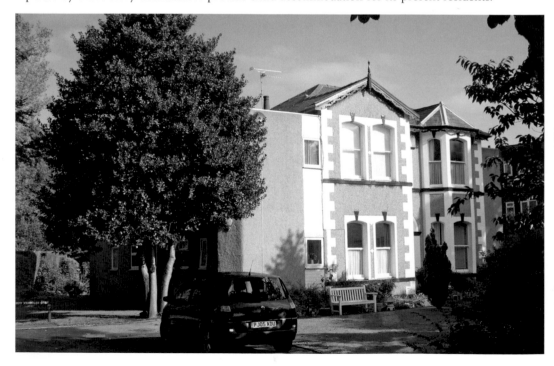

Victoria Road, Freshfield Road Corner; Larswood, Photographed in the 1960s

The distinctive house originally on this site unfortunately lost its tower prior to demolition and replacement by the current block of flats. The house was lived in latterly by a Dr Roberts, a local practitioner. Prior to the planting of the coastal pines around the end of the nineteenth century, there would have been a good view from the tower out to sea, so perhaps the house was originally lived in by someone connected with shipping.

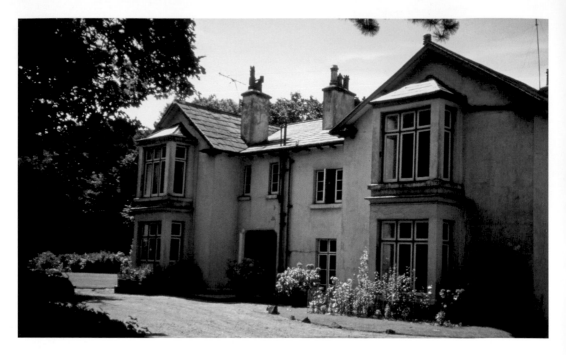

Ravenmeols, 'Firwood', Photographed in the 1960s

This spacious and attractive house, built by Dr Richard Formby, stood in spacious grounds in Alexandra Road. Its grounds included the first plantation to be planted on the Sefton Coast in the eighteenth century (hence its name). All that remains today are its foundations. An application was made some years ago to rebuild the house but being in the coastal zone, planning permission was not given.

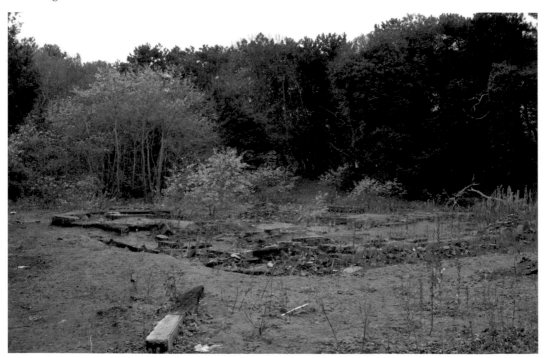

1 and 2 Albert Road, 1988
These two large, semi-detached houses are survivors of the few that were built by the Formby Land Company in the dune area, then named 'Formby-by-the-Sea', at the end of the nineteenth century. This was an unsuccessful attempt to create a seaside resort. Unlike most of the others, which have now been demolished, these houses have not been altered in the least and have remained constantly occupied and well maintained.

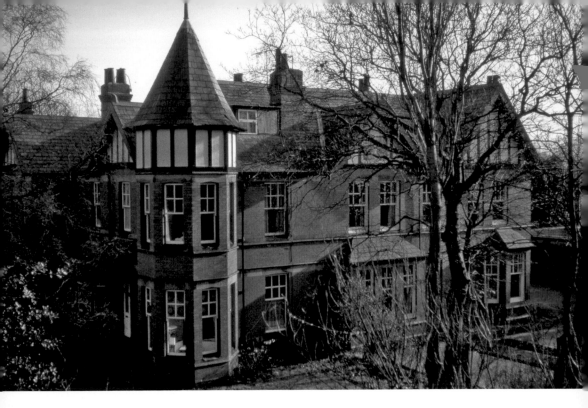

Barkfield House, Barkfield Lane, 1987
As Formby developed in the late nineteenth century, it seems to have been a practice to build rather distinctive houses on prominent corner sites. This one on the west side of Barkfield Lane is a good example, though now flats.

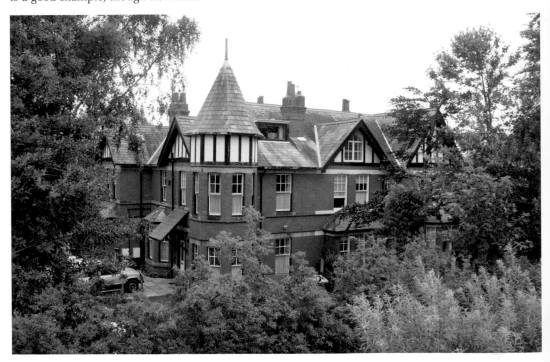

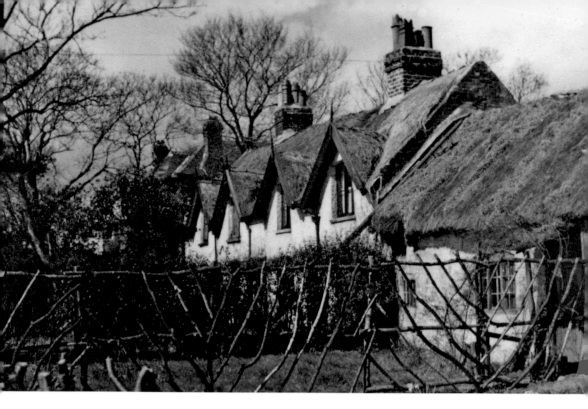

Duke Street, Duke's Cottages. Photographed in the 1950s
These old cottages were modernised and the single-story thatched cottage at the end was replaced by a new building, which became known as the Beehive Café.

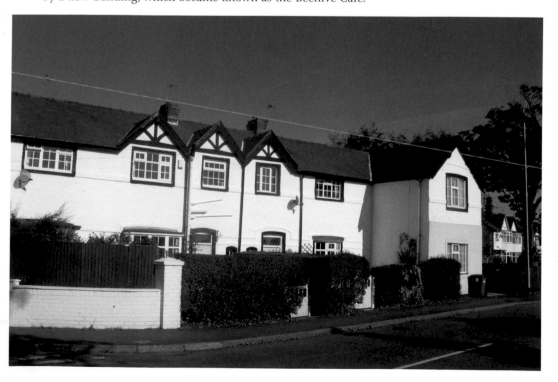

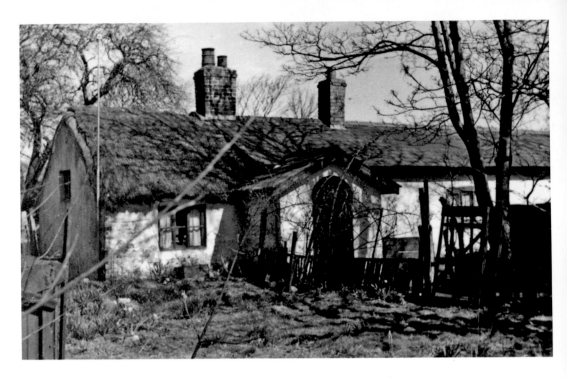

Kirklake Road, Cave's Cottages

These thatched cottages may have looked picturesque but lacked mains drainage and were in poor condition when they were condemned long before being demolished. They were then replaced by new houses. Recently, a start was made on building a further seven small houses immediately in front, bordering on Station Hill, but at the present time, building has ceased and the site has become very unsightly indeed.

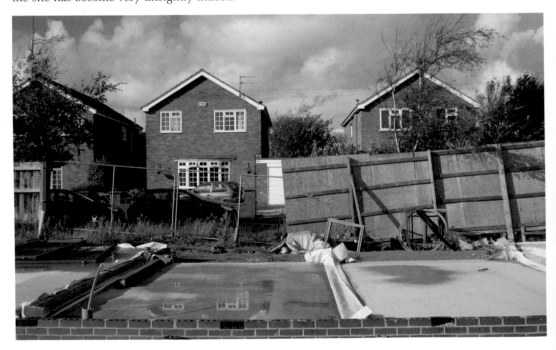

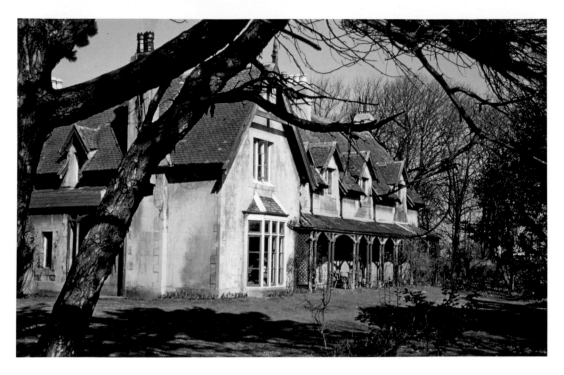

Kirklake Road, 'Kirklake Bank'. Photographed 1969

This house in Kirklake Road was also built by Dr Richard Formby and is mentioned by Katherine Jacson in her book *Formby Reminiscences*. She portrayed life in Formby at the end of the nineteenth century. It continued to be lived in by descendants of the former manorial family for many years but has now been replaced by modern housing.

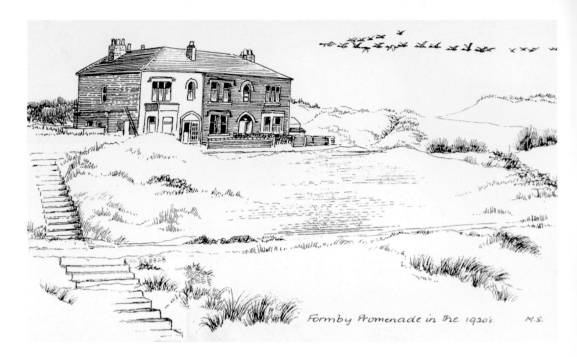

Formby Promenade in the 1920's. M.S.

Ravenmeols, 'Formby-by-the-Sea' Promenade

This sketch by Muriel Sibley, taken from a photo from the 1930s, demonstrates how the Formby Land Company hoped to develop their proposed Formby-by-the-Sea resort overlooking an extensive double-decker 1,000-foot-long promenade. The house still stands today, much enlarged and still used. The promenade, however, has become buried by sand and only part of the upper flight of steps down to the beach can (with difficulty) still be found. A vast area of dunes has built up in front of the promenade, but the house still commands beautiful views across Liverpool Bay to the Welsh coast and the shipping entering and leaving the Mersey.

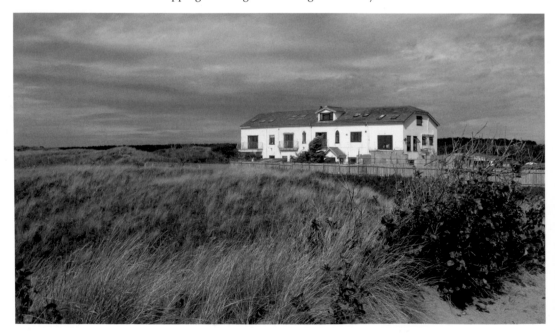

chapter 6

Highways and Byways

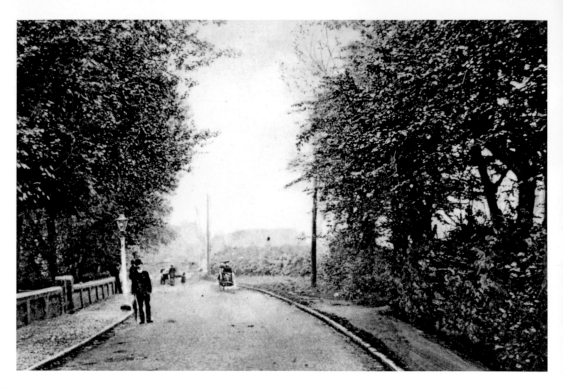

Brows Lane, Looking East, Towards the Village Around the Early 1900s
Most of the houses on the south side were built in 1926. There were some older houses on the
north side. It can now get very crowded when full of parked cars!

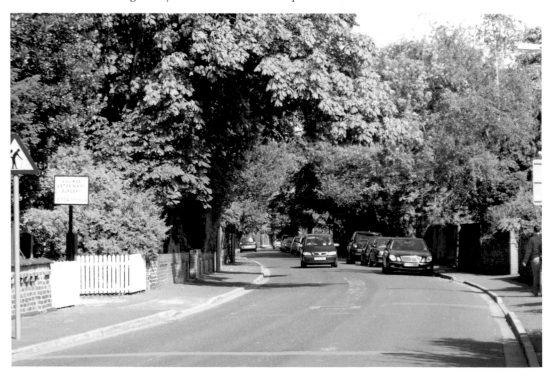

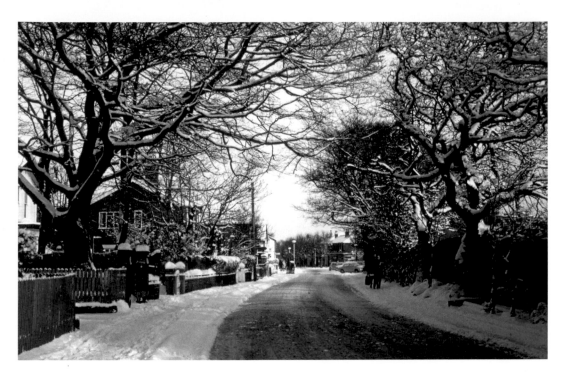

Brows Lane, c. 1950s
Moving towards the village, there is pleasantly little change here, but the removal of the fence on the right during the construction of the new swimming pool provides an increased sense of spaciousness. Unfortunately, some of the trees had to be removed and an access provided for vehicles bringing parties of schoolchildren to the pool.

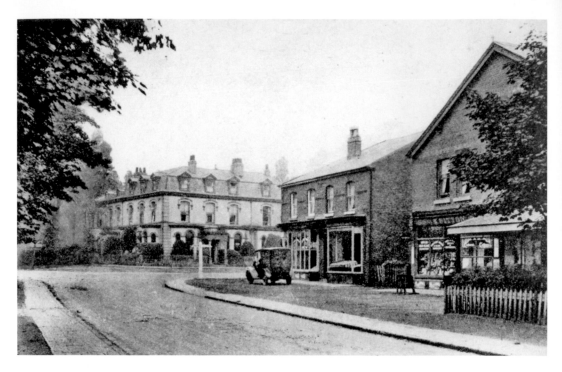

Church Road, *c.* 1930s
The Grapes Hotel proudly marks the entrance to Formby's only conservation area. The block of shops on the right is, however, within the area. The old vehicle parked on the pavement by the corner unknowingly initiated the creation of a parking area. This, of course, helps trade and makes for a safer corner.

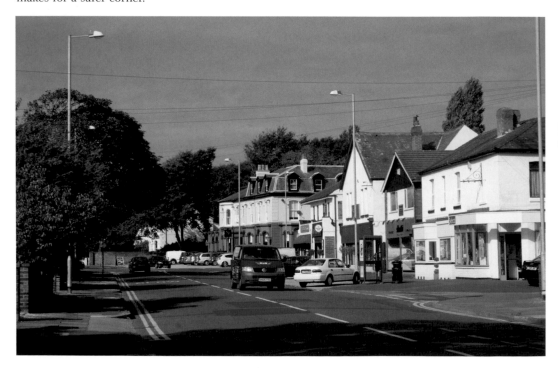

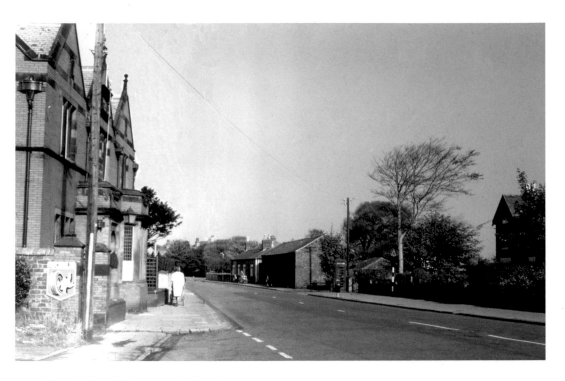

Church Road. Photographed 1964
The police station on the left was built over 100 years ago. On the opposite side of the road, the farm has gone and a typical row of small modern shops created in its place.

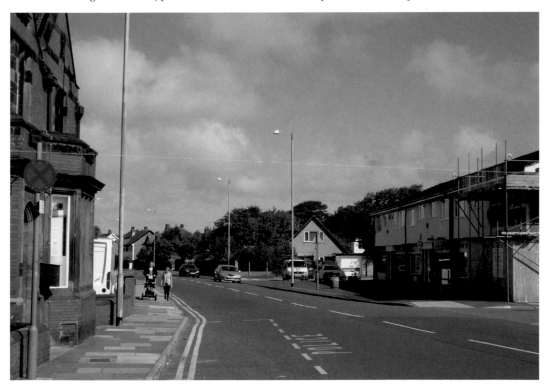

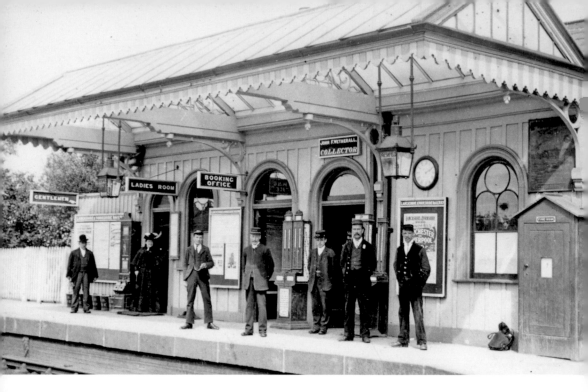

Freshfield Station, Photographed 1912

Established later than Formby station at the instigation of Thomas Fresh, the first 'Inspector of Nuisances' in Liverpool, the station was named after him and in turn gave its name to the area around it. Next to the station was a manure siding where night-soil from Liverpool was brought for the use of local farmers who found it very beneficial in fertilising our light, sandy soils, so enabling the development of asparagus cultivation here in the mid-nineteenth century. Much of the old station building has gone. The house remains but is no longer the residence of a stationmaster.

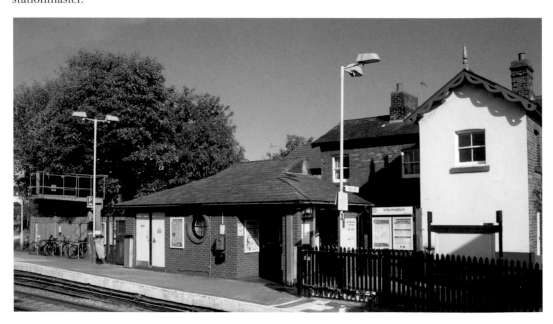

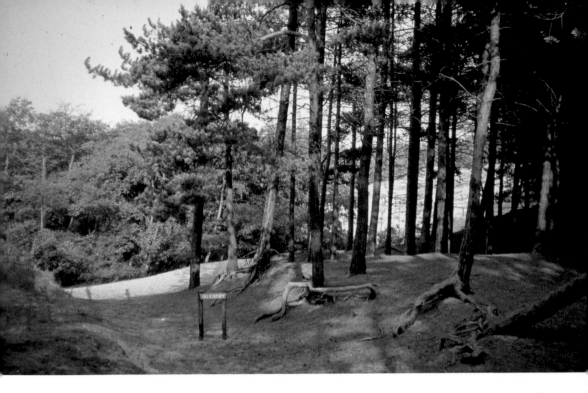

Fisherman's Path, Photographed 1975

The walk down this path to the shore is very pleasant and popular. The purely sandy surface seen in the earlier photograph has recently been compacted and made easier to walk on. The pine trees were planted here about 100 years ago and provide habitat for a decreasing colony of red squirrels. They also provide a wind-break for the adjacent and old-established golf course.

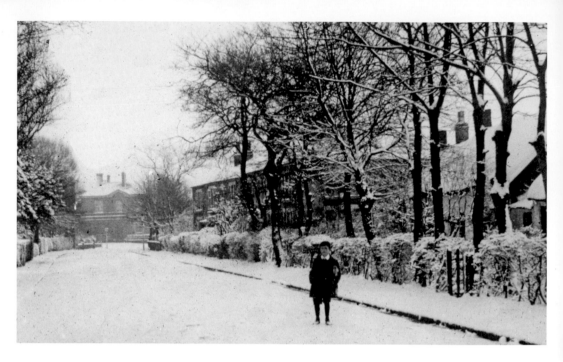

Duke Street in the Snow

Being close to the Irish Sea, Formby gets little snow, and if we do, it doesn't last long. This main road leading from the coast to the former Blundell Arms hotel seen in the distance is a busy one, usually full of traffic. Since the early photograph, the thatched house on the right, behind the trees, has been replaced by a modern one and most of the trees have gone.

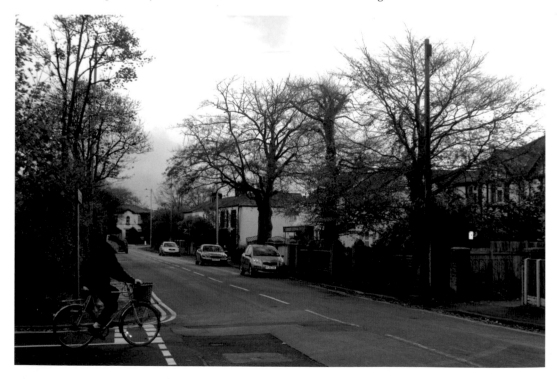

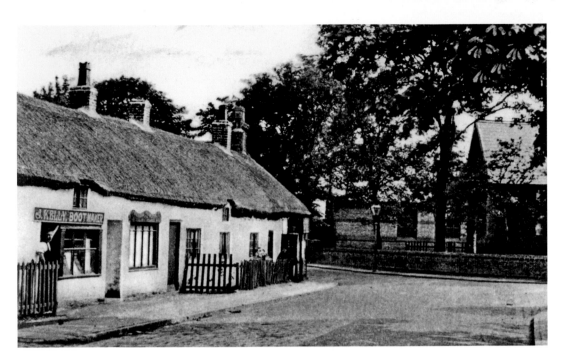

Church Road / Liverpool Road / School Lane Junction, c. early 1900s
This busy intersection was once much narrower than it is today. This picturesque row of cottages standing in front of the present building line included a boot maker.

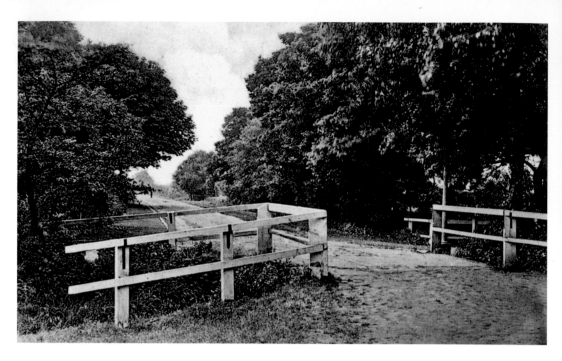

Moss Side; The Bridge Over Downholland Brook. Photographed 1905
The moss-land inland to Formby is an extensive, formerly marshy area, now drained and providing good agricultural land. Downholland Brook, a tributary of the River Alt, was straightened many years ago, but the original course flowing beneath this bridge still runs and these fences are to help avoid accidents.

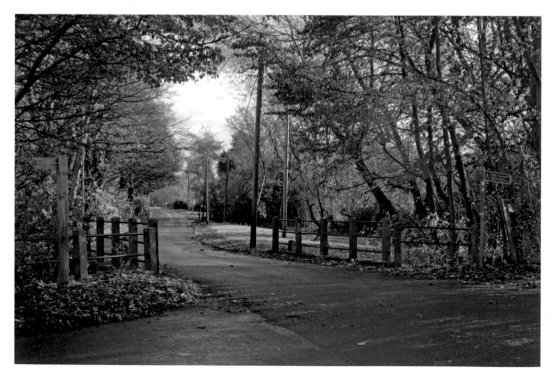

Old Town Lane, Looking East. Photographed 1962
This lane is thought to be one of the oldest areas of Formby. The old cottage on the right was demolished about thirty years ago, giving way to a new cul-de-sac. Both sides of this road are now fully developed with modern houses but still pleasant gardens.

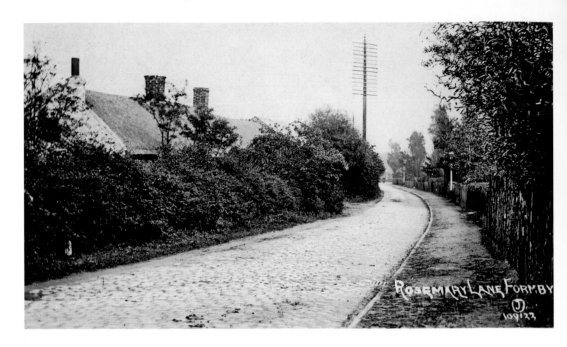

Rosemary Lane, Looking Towards the Village

This old lane, leading from the village towards the shore, had at least one of Formby's thatched cottages when the first photograph was taken. It was otherwise built up in the Victorian period. It now has more car-owners than when the first photo was taken, and traffic to and from the village is now more of a problem than the lower photo suggests.

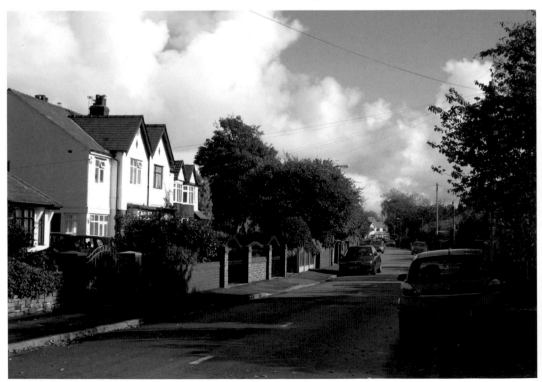

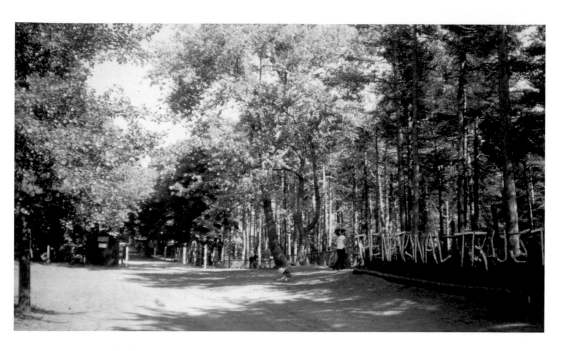

Victoria Road. The National Trust Entrance in 1975

The earlier photograph was taken just ten years after the property was purchased under the aegis of 'Enterprise Neptune' by the National Trust. Previously a quiet, secluded area of woodland with an adjacent asparagus farm, it has now become a honey-pot destination with nearly half a million visitors a year. Unfortunately, the car park overlooking the beach at the end of this road is now eroding into the sea, and in a sense, this popular reserve has become a victim of its own success. Unfortunately, its famous colony of red squirrels is also succumbing to a viral disease.

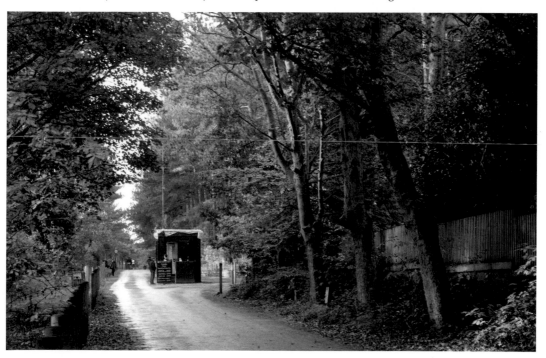

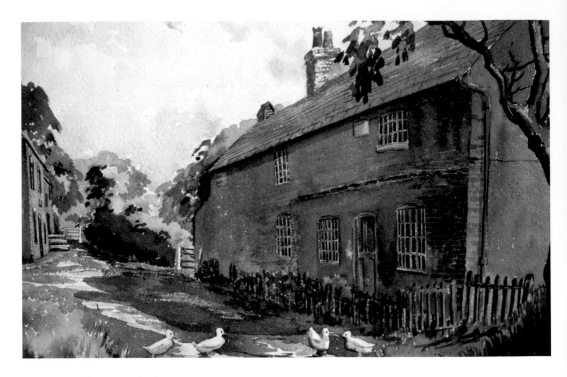

Bills Lane. Photographed 1970

It is not really known how Bills Lane got its name, but it used to be said that it may have been after a Tyrer, as a branch of that family built Lea farm in the 1700s and lived in there until comparatively recently. Unlike most farms in this area, it was an arable rather than dairy farm. Peas, beans, carrots and cabbage were sent to the Liverpool market by cart. Apples, pears and soft fruit were also grown.

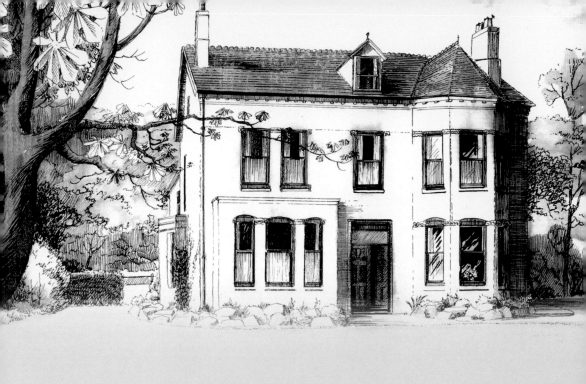

chapter 7

Change of Scene

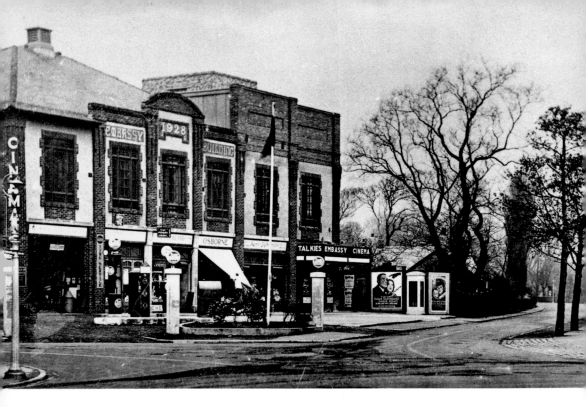

The Embassy Cinema Building, Photographed 1930

This 1928 corner block just within the Green Lane conservation area is only just about recognisable. The shops have changed hands, the rather elegant, first-floor windows were boarded over and what was a garage forecourt is now used simply for parking. The former Embassy Cinema on the second floor has been used for many things from an ice rink to a furniture showroom and more recently a snooker club. Nothing seems to last long and the building's external appearance within Formby's one conservation area has now been improved by removal of the unsightly cladding.

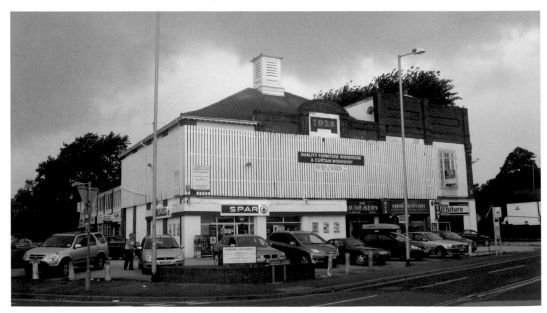

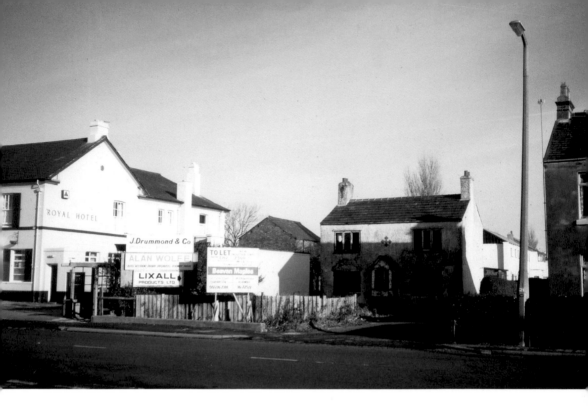

The Victorian Royal Hotel in Liverpool Road
With its spacious bowling green, the hotel was much used by troops stationed at Altcar during the Second World War. Behind it stood the somewhat strangely named Recipricocity Brewery, stretching from the residential house in front for some distance behind the hotel. These buildings have now become the nucleus of the Mayflower Trading Estate. A bathroom and sanitary supply firm have extended forward from the former house, and the pub itself has also extended.

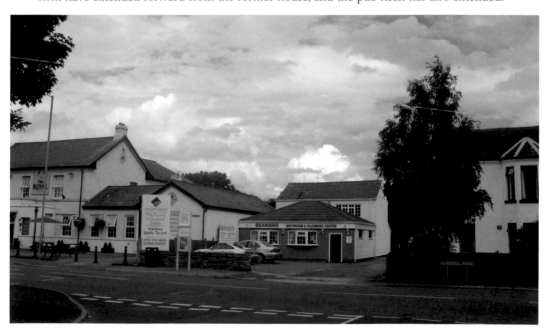

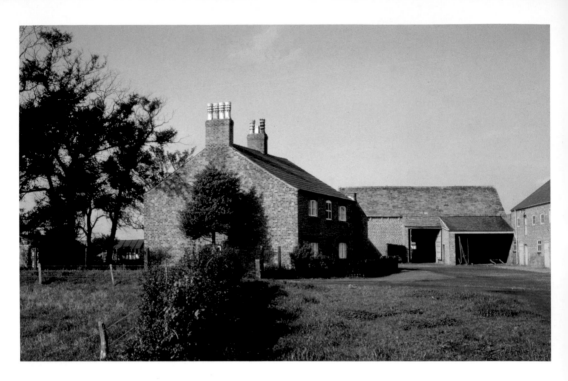

Lovelady's Farm, Photographed 1978

These farm buildings, at the corner of Liverpool Road coming into Altcar from the bypass, have all been converted into housing units. This epitomises the change in Formby from its original status as an agricultural community to its present status as an almost purely residential one. However, old barns can make excellent dwellings, and it is good to see them preserved.

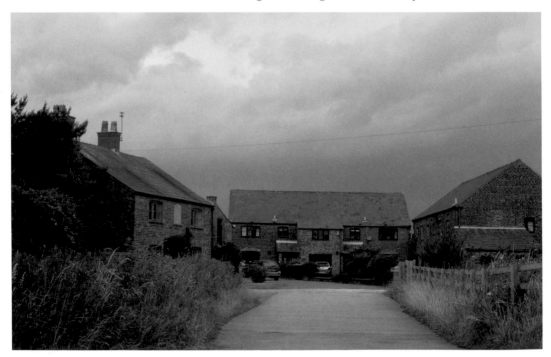

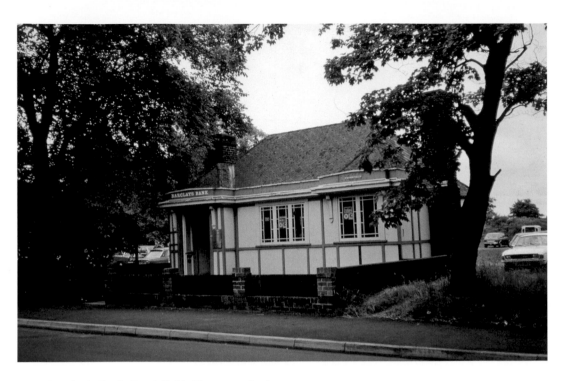

Barclay's Bank, Freshfield, Photographed 1979
This attractive small 'country' branch of Barclay's has given way to flats and a bus turning circle. The flats have parking at the rear and are conveniently near to the station.

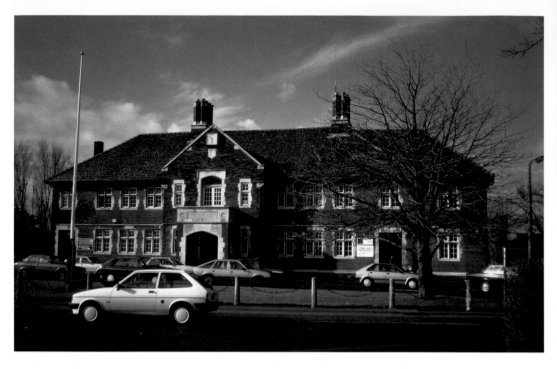

Formby Urban District Council Offices, Freshfield Road. Photographed 1980s
Built in 1927, its prime function ceased when Formby became part of Sefton Metropolitan Borough in 1974. As it was still being used for meetings and many other services, including magistrates courts and coastal management, many Formby residents were very sad when Sefton MBC decided to demolish this handsome building and sell the site for the building of a massive retirement block.

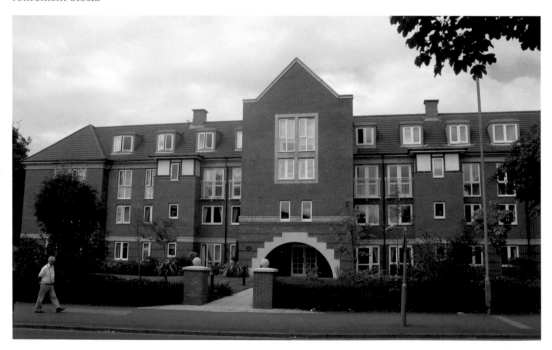

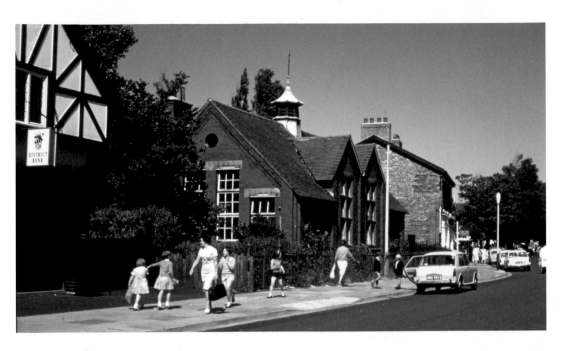

Holy Trinity School, Chapel Lane

Built in 1905 on the site of thatched cottages and small shops. By 1970, the wheel had turned full circle and shops were being built on the site of the school. In the 1950s, an extra classroom was built and that is all that remains of the old school, now in use as part of a series of parish rooms. Holy Trinity School transferred to a new building in Lonsdale Road, and the earlier building was demolished in the early '60s, but has now moved again to Paradise Lane, amalgamating with St Peter's School. The bank remains, but the school site is now a row of shops. Trees have been planted to maintain a tree-lined Chapel Lane. As the lady on the bike demonstrates, it is still safe to cycle to the shops in Formby village!

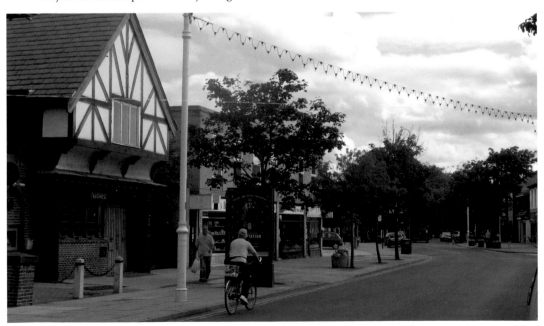

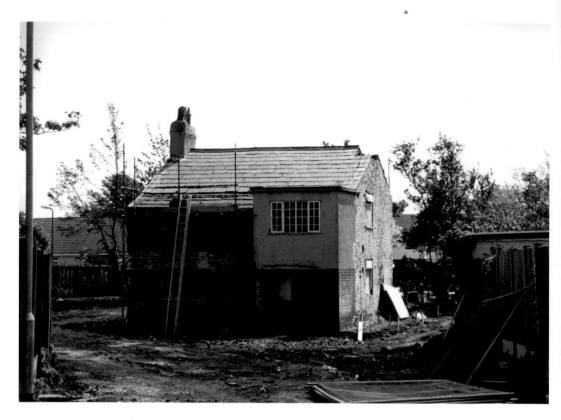

Rose Cottage, From Cross Green

An unmade path ran to meet Redgate at a corner that, until the late 1950s, was simply open fields. Rose Cottage stood at the beginning of this ancient path to the town fields. In the last year or so, its rural aspect has been completely altered. It has now been drastically modernised, separated by iron railings from the pathway and converted to a modern residence.

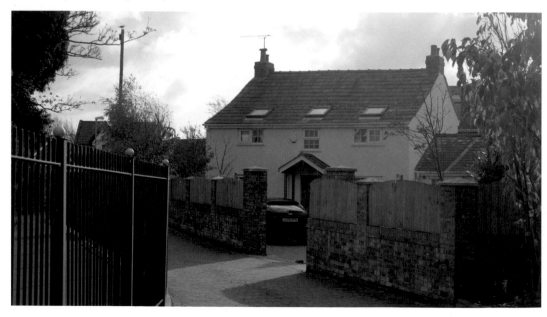

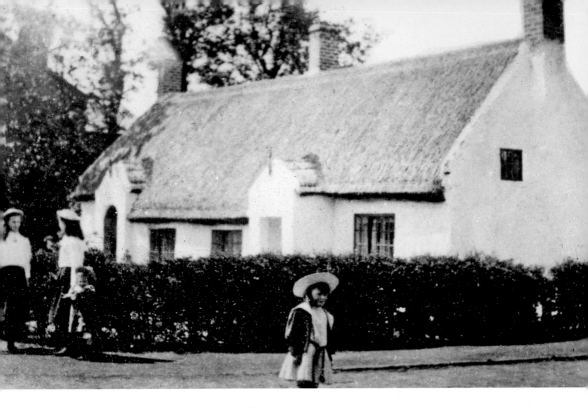

The Corner of Chapel Lane and Halsall Lane *c.* 1900

Here, a stylish branch of Barclay's bank replaced a traditional thatched cottage, which unfortunately, was accidentally destroyed by fire many years ago. Not only do buildings change but so apparently do children. The child in the foreground of the older photograph might be mistaken today for a girl but he was in fact very much a boy (Clayton Reynolds). He became successful in Canada but kept in touch with Formby for many years.

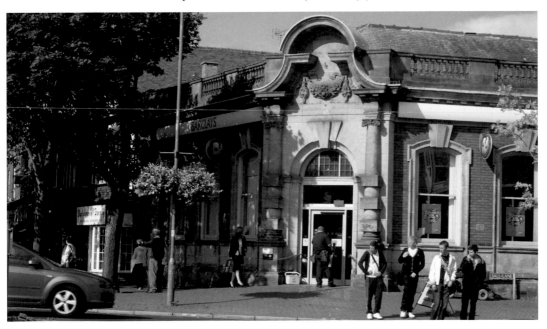

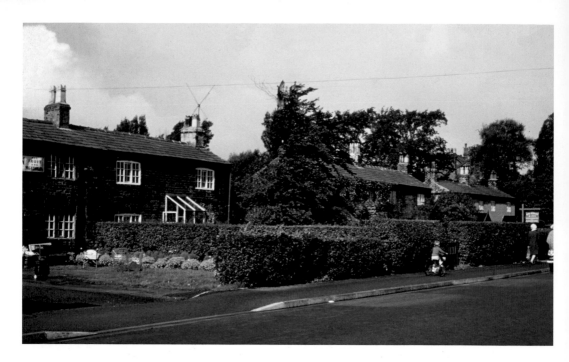

Halsall Lane, Photographed 1966

As the shopping area expanded out of Chapel Lane to make way for our first supermarket, we also lost these attractive cottages, typical of old Formby, They had Lancashire sliding-sash windows and long front gardens. One of these was, for many years, run by an excellent nurseryman and rose-grower, Mr Wright, who then moved to a new location across the bypass. Luckily, new trees were planted to hide the brash new shops with offices above.

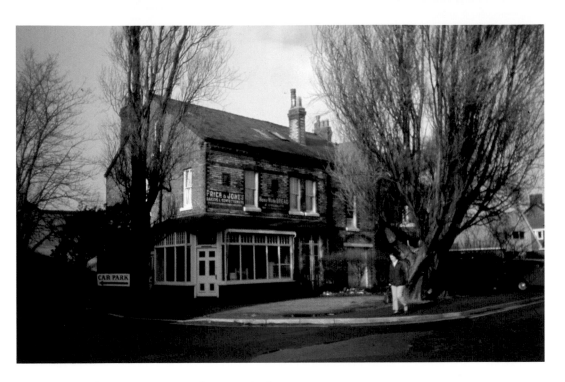

Corner of Furness Avenue, Photographed 1972
Previously said to have been a private school and hostelry, this was formerly Price & Jones'
bakery on the corner of Halsall Lane and Furness Avenue. Here, bread was baked from before
the beginning of the twentieth century until it was demolished for the construction of this new
block of shops in 1976.

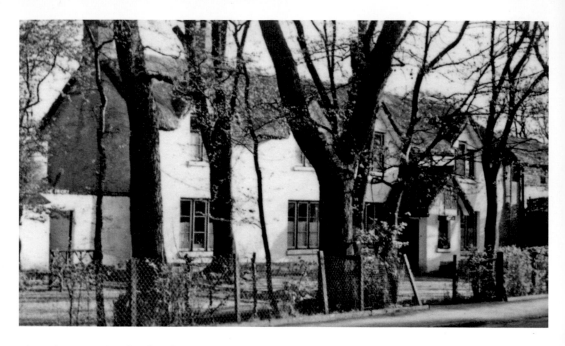

The Priory, Previously The Elms, Brows Lane

The old thatched house with an air of mystery was lived in at one time by a lady, much in demand as a soloist who rendered her songs at concerts in the Grapes Assembly Room. It was then bought with an orchard extending down Elbow Lane by a Mrs Van der Vord who ran the house as a guesthouse. A parrot often hung in its cage from a tree in the front garden and its cries and wolf whistles could be heard even from the station. The Elms was reroofed in slate by its new owner, who renamed it The Priory. In the early '60s, it was pulled down and the present row of shops, including Pritchards excellent bookshop, now stands here and cars now park where the trees grew by the front gate.

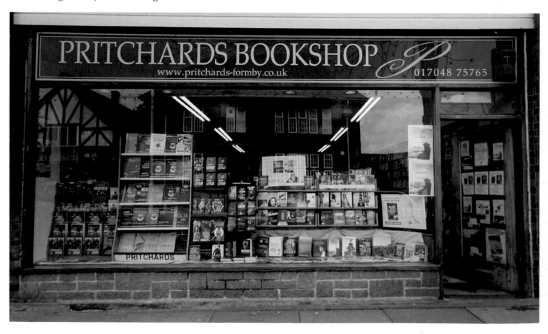

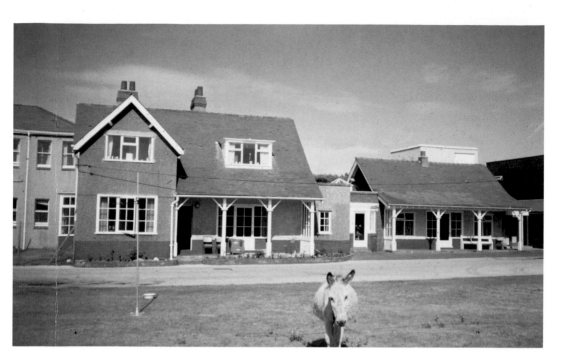

St Joseph's Home, Blundell Avenue, Freshfield

The original house and annexe are thought to have been built by the Weld-Blundell family, who owned this area of Formby, for recuperative care of a sick young member of the family in the 1930s. It was subsequently taken over by an RC children's society, at first as a children's convalescent home. By 1940, the building was being used for evacuated Liverpool children, mainly from Catholic schools in Seaforth and Litherland. Some still have vivid memories of their stay here. In the 1950s, the home was being used for care of children with cerebral palsy, but now, much enlarged, it provides 'quality care for people with severe learning and physical disabilities' under the management of the Frances Taylor Foundation.

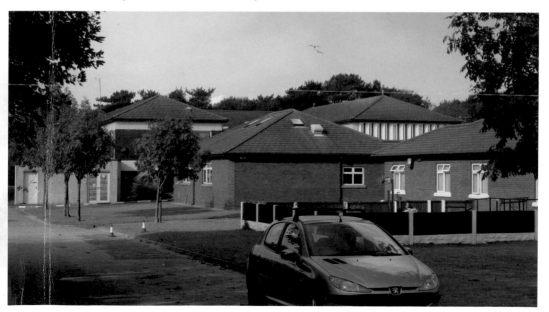

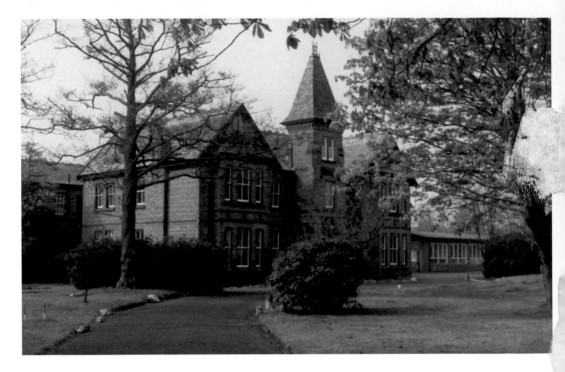

Shaftsbury House

This was a private 'lunatic asylum' run by a doctor, Stanley Gill, and later his son. Subsequently, it became St Vincent's School for boys but was demolished a few years ago and is now a rather pleasant residential estate. As a private mental hospital, it had its own concert hall, and at the time that Holy Trinity Church was trying to raise funds to build its church hall, fund-raising concerts were held at Shaftsbury House, at which Percy French, a cousin of the vicar, was the star attraction. It was after one of these that the famous artist and musician unfortunately collapsed and died. It is good that many of the existing trees have been kept.

chapter 8

Conservation of the Built Environment

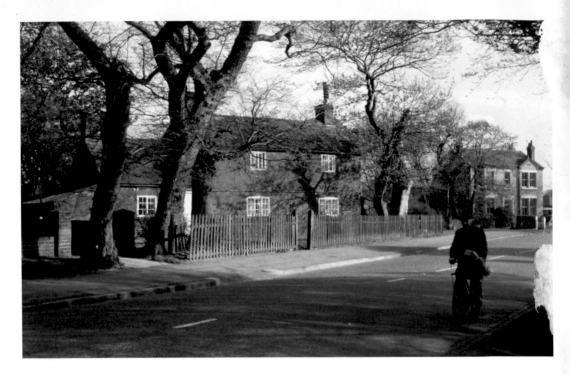

Ivy House Farm, Liverpool Road, Photographed 1969

This former farmhouse originally marked the entrance to Formby Fields, Formby's town fields, an agricultural system that continued to be used in Formby until the mid-nineteenth century or later. In the later nineteenth century, Altcar Road, an entirely new road, was constructed, improving the route between Formby and Altcar. This new road cutting through the back of Ivy Farm house must have caused some consternation at the time! Despite this, the house itself did not alter until just two years ago when it changed hands and was radically 'improved' and enlarged.

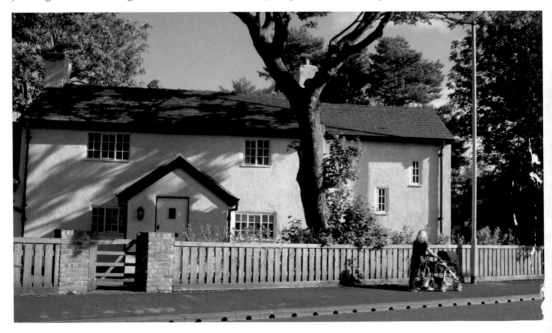

Thimble Hall, Formerly Ivy Cottage, Green lane

This is thought to have originally been an out-building of the neighbouring May Cottage, owned by a fisherman. It has clearly risen in the world since that time and is now a house in its own right with an upper floor, extended beyond the chimney stack and provided with a handsome bay window overlooking Green Lane. May Cottage is built with a strong oak-beam frame with cruck construction and wattle walling. Two centuries ago, May Cottage was actually two. It was roofed with thatch but is now tiled.

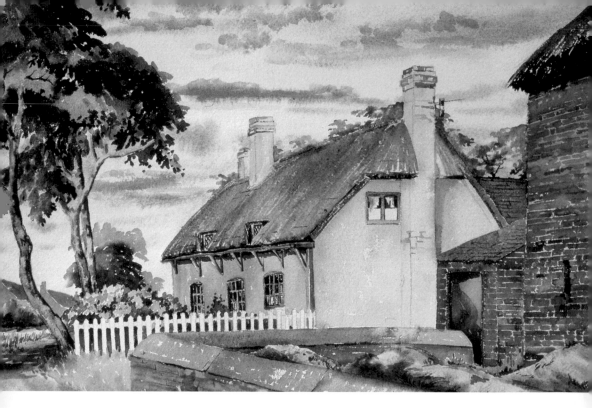

Hoggs Hill Farm

Formerly isolated, stands on the lane of the same name, the Formby/Altcar boundary. The cottage was first occupied by Marjorie and William Jump in 1597 and subsequently by their sons, Gilbert and Rupert. Like many small farms, the back of the farmhouse faces the lane.

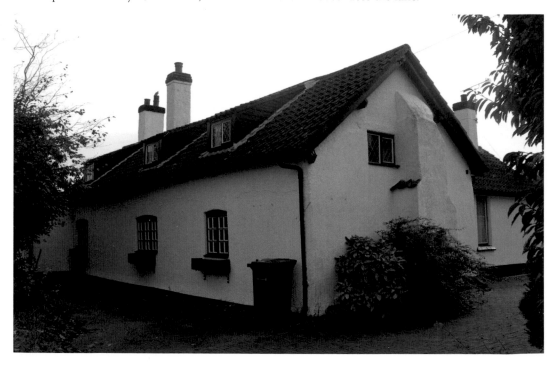

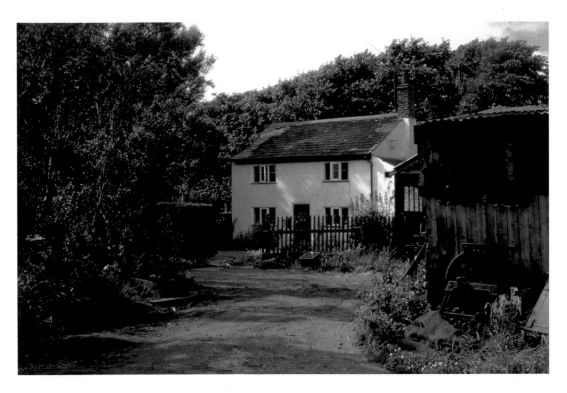

Ravenmeols Farm, Kew Road, Photographed 1968

At the southern end of Formby, looking out across the fields towards Hightown, this old farmhouse, a listed building, has a date stone inscribed 1733. It still appears to have a stone slate roof. The windows have casements and horizontally sliding sashes. It is, however, no longer a farm, but its present owners have plans to start kennels there.

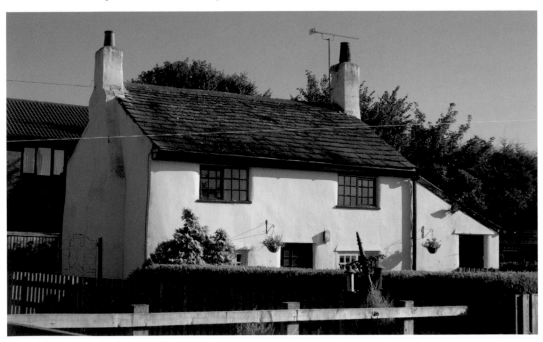

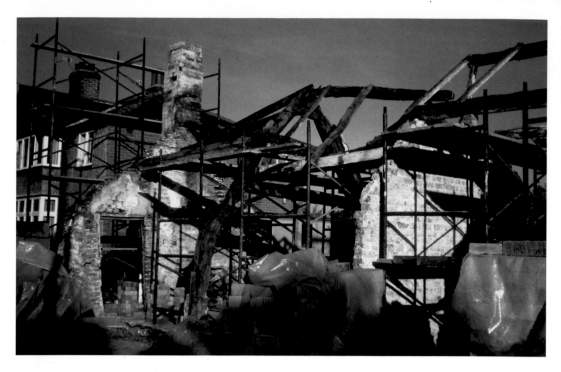

Stoneyhurst Cottage, Priest House Lane
This old cottage was rather drastically renovated some years ago. Formerly a listed building, the renovation revealed the original 'cruck' frame structure very well. This form of construction was formerly widespread in this area.

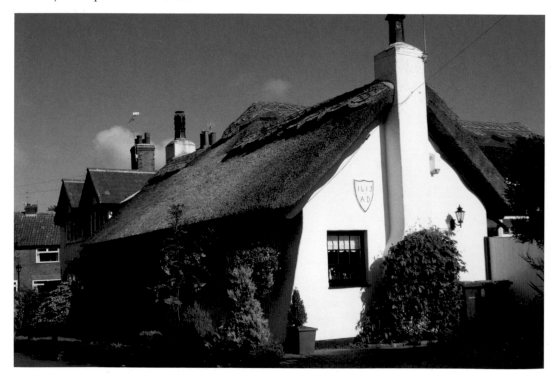

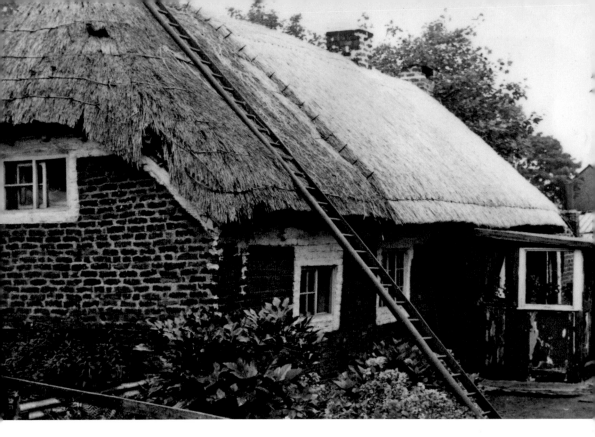

Deans Cottage (Being Re-thatched)

Formerly in Ravenmeols Lane, now Park Road, this 'listed' thatched cottage is probably sixteenth century and cruck framed. It has a half-hipped roof. The windows have small pane glazing, some with horizontally sliding sashes. The interior originally had a central full-height room with exposed crack trusses. Interior walls were wattle and daub. The property was at one time a nursery growing vegetables. After a new road was constructed to its rear in the 1960s, the cottage was given a new address! The thatch has to be replaced about every thirty years.

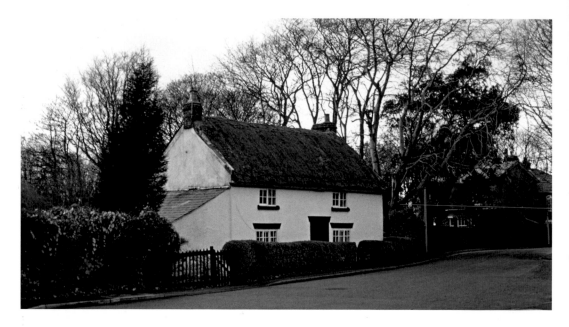

Church Cottage, Green Lane

A charming 'rough-cast', eighteenth-century thatched cottage opposite St Peter's church (listed in 1966). The twentieth-century front entrance has been moved! It retains, however, its timber guttering with sloping open downspout. It was once the home of Mr and Mrs Charles Aindow, who had lived there for forty-five years. The old cottage was then nearly 300 years old and had been a farmhouse until 100 years previously. A room at the far end of the cottage used to be the dairy and another was known as the paddy room because it was used by Irishmen who came over for the potato picking. Although it appears small, it had a total of nine rooms, including a large pantry. Support for the roof was from stout planks and thick wooden pegs. The thatch had to be renewed every four or five years and cost £150 each time. Blackbirds were blamed for making holes in the roof!

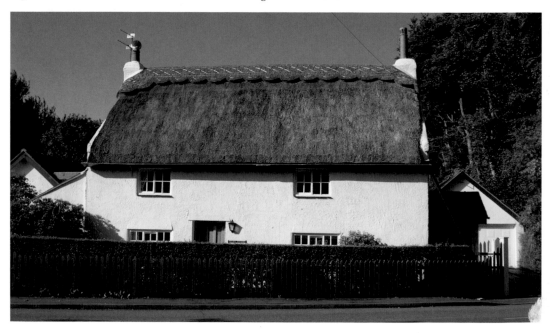

(Right) Garswood, 1982
This house has been described as a 'Victorian Gem'. Older residents may recall peacocks strutting on the lawns. It is said to be one of the most interesting and unspoiled Victorian houses in Formby, retaining a striking cast-iron veranda extending between canted bay windows. It has a balustrade, five twisted columns supporting arches, and wrought-iron gates. Inside, it has a wrought-iron staircase and mahogany doors. Outside, it has a courtyard and stables and blue tiled walls. During the Second World War, soldiers were billeted in it.

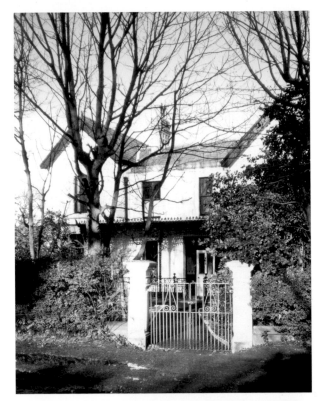

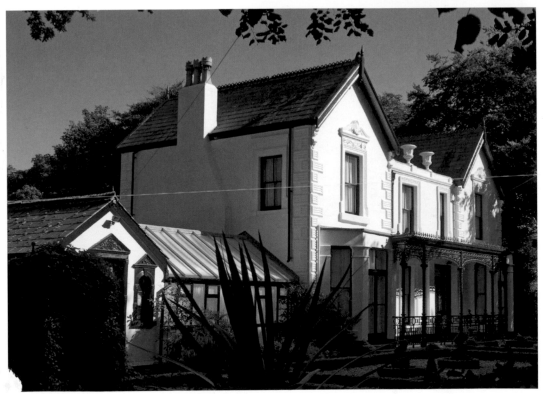

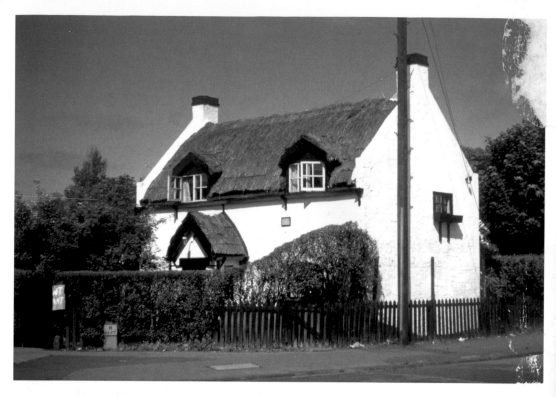

Old Spanker's Cottage, Corner of Ravenmeols Lane / Liverpool Road

A listed building, probably eighteenth century, with thatched roof and horizontally sliding sashes. This cottage is said to have got its name from the time it was lived in by the local midwife who gave many a new baby its first 'gentle smack'. There are, however, other explanations!

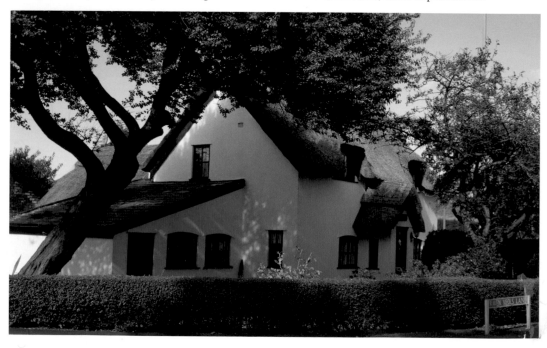

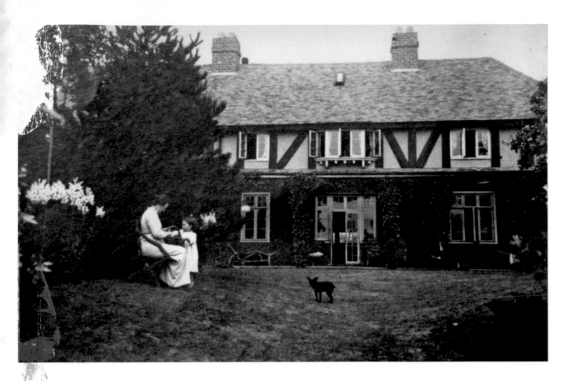

Sandhill Cottage, Albert Road

This charming listed building, situated within the intended resort of 'Formby-by-the-Sea', divided into two, was built about 1880 by A. H. Mackmurdo, the well-known architect and leading advocate of the Arts and Crafts Movement. The garden front, seen here, has a timber veranda and the windows have small pane casements. This is a rare example of a building by this nationally important architect.

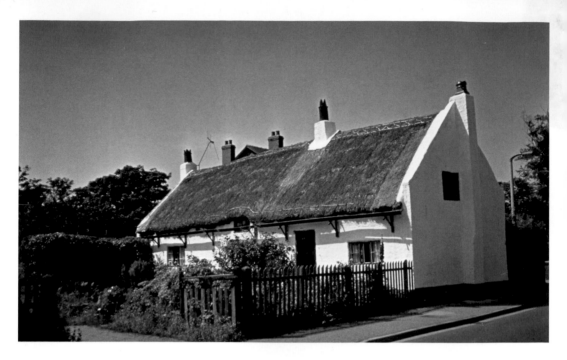

White Cottage, Gores Lane

This picturesque, eighteenth-century, 'listed' cottage still has its thatched roof and cruck frame. The ground-floor windows have three-light horizontally sliding sashes and one or two lights with an 'eyebrow' dormer. It is currently for sale for a price that would have astonished its previous residents!

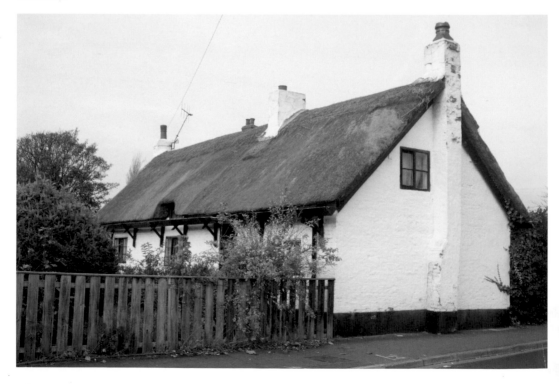